T0143745

Remembering

Memphis

Gina Cordell and Patrick O'Daniel

TURNER
PUBLISHING COMPANY

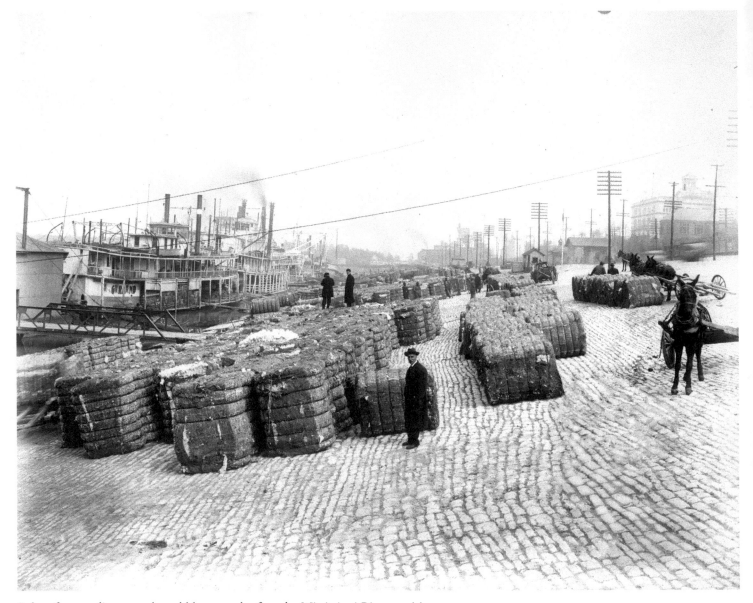

Bales of cotton lie across the cobblestone wharf on the Mississippi River awaiting transport.

Remembering Memphis

Turner Publishing Company
www.turnerpublishing.com

Remembering Memphis

Copyright © 2010 Turner Publishing Company

All rights reserved.
This book or any part thereof may not be reproduced or transmitted
in any form or by any means, electronic or mechanical, including
photocopying, recording, or by any information storage and retrieval
system, without permission in writing from the publisher.

Library of Congress Control Number: 2010902279

ISBN: 978-1-59652-605-1

Printed in the United States of America

ISBN: 978-1-68336-853-3 (pbk.)

CONTENTS

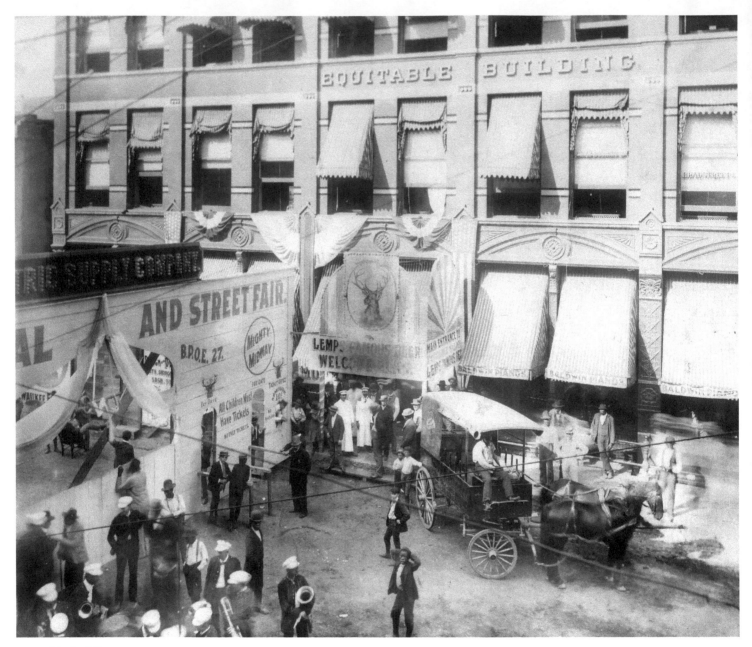

Equitable Building, 1890s.

ACKNOWLEDGMENTS

This volume, *Remembering Memphis,* is the result of the cooperation and efforts of many individuals and organizations. It is with great thanks that we acknowledge the valuable contribution of the following for their generous support:

First Tennessee Bank
Memphis Light, Gas & Water
Memphis Public Library

We would also like to express our gratitude to Dr. Wayne Dowdy for providing research and contributing in all ways possible.

And finally, we would like to thank the following individuals for their valuable contribution and assistance in making this work possible:

Dr. Jim Johnson, Memphis and Shelby County Room, Memphis Public Library
Patricia LaPointe, Memphis and Shelby County Room, Memphis Public Library
Dr. Jim Johnson, Senior Manager, History Department
G. Wayne Dowdy, Archivist, History Department
Patricia LaPointe, Curator, Memphis and Shelby County Room
Betty Anne Wilson, Assistant Director for Library Advancement

Kim Cherry, Vice President of Corporate Communications, First Horizon National Corporation

PREFACE

Memphis has thousands of historic photographs that reside in archives, both locally and nationally. This book began with the observation that, while those photographs are of great interest to many, they are not easily accessible. During a time when Memphis is looking ahead and evaluating its future course, many people are asking, How do we treat the past? These decisions affect every aspect of the city—architecture, public spaces, commerce, and infrastructure—and these, in turn, affect the way that people live their lives. This book seeks to provide easy access to a valuable, objective look into the history of Memphis.

The power of photographs is that they are less subjective than words in their treatment of history. Although the photographer can make subjective decisions regarding subject matter and how to capture and present it, photographs seldom interpret the past to the extent textual histories can. For this reason, photography is uniquely positioned to offer an original, untainted look at the past, allowing the viewer to learn for himself what the world was like a century or more ago.

This project represents countless hours of review and research. The researchers and writers have reviewed thousands of photographs in numerous archives. We greatly appreciate the generous assistance of the archivists listed in the acknowledgments of this work, without whom this project could not have been completed.

The goal in publishing this work is to provide broader access to this set of extraordinary photographs that seek to inspire, provide perspective, and evoke insight that might assist people who are responsible for determining Memphis' future. In addition, the book seeks to preserve the past with adequate respect and reverence.

The photographs selected have been reproduced in vivid black-and-white to provide depth to the images. With the exception of touching up imperfections that have accrued with the passage of time and cropping where necessary, no changes have been made. The focus and clarity of many images are limited to the technology and the ability of the photographer at the time they were recorded.

The work is divided into eras, showing Memphis from the late nineteenth century to recent times. In each of these sections we have made an effort to capture various aspects of life through our selection of photographs. People, commerce, transportation, infrastructure, religious institutions, and educational institutions have been included to provide a broad perspective.

We encourage readers to reflect as they go walking in Memphis, along the riverfront, or through the Peabody Hotel, imagining the riverboats that once lined the Mississippi and many buildings, long since demolished, that lined Front and Main streets. It is the publisher's hope that in utilizing this work, longtime residents will learn something new and that new residents will gain a perspective on where Memphis has been, so that each can contribute to its future.

—*Todd Bottorff, Publisher*

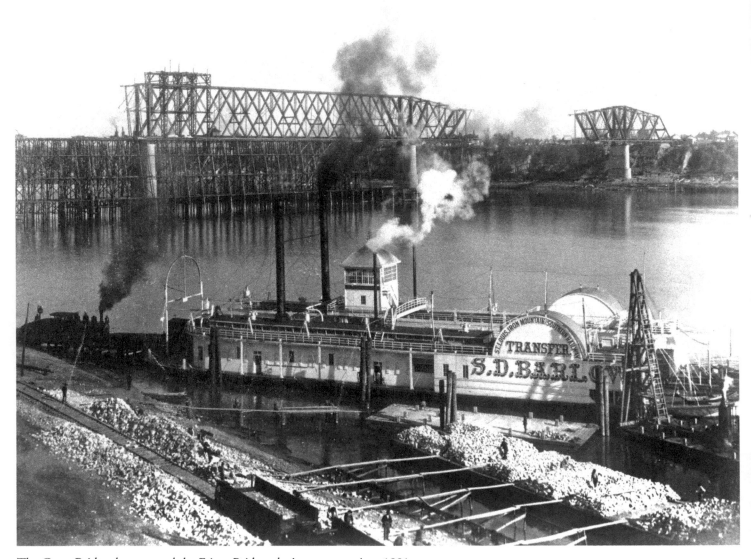

The Great Bridge, later named the Frisco Bridge, during construction, 1891.

To the Turn of the Century

(1880s–1899)

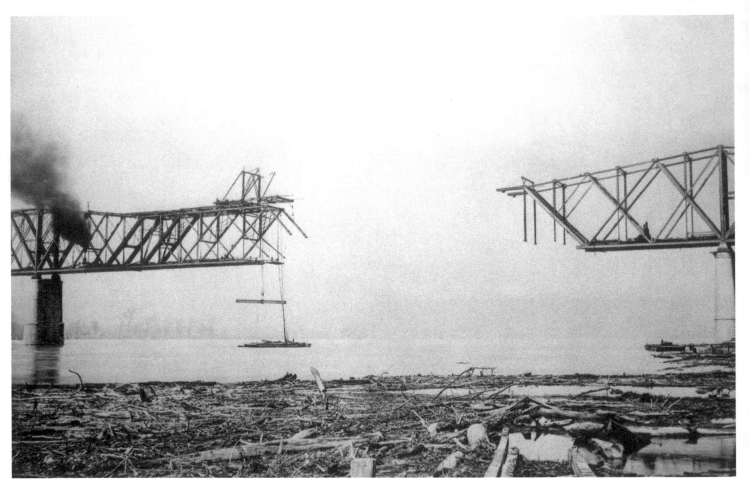

Erection of the east intermediate span of the Frisco Bridge, March 2, 1892.

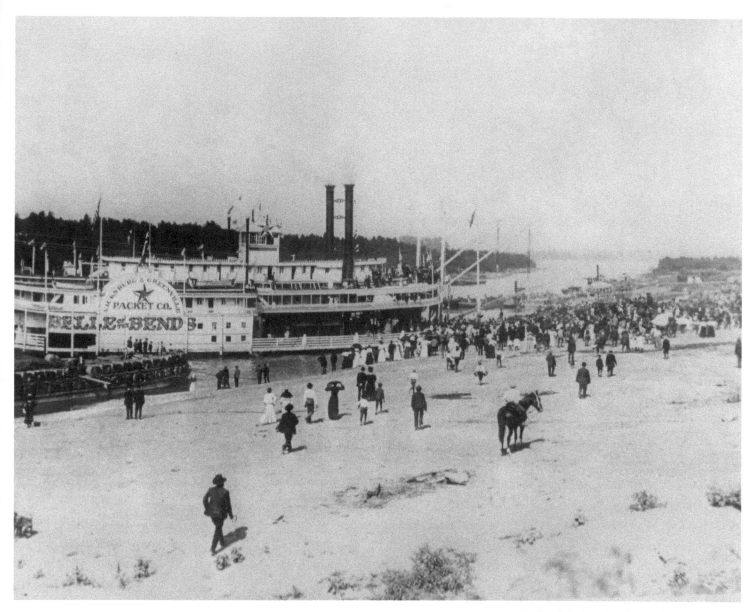

Belle of the Bends at Memphis, circa 1899.

Opening of the Great Bridge at Memphis on May 12, 1892. The bridge was only the second to span the Mississippi River, after the Eads Bridge was constructed at St. Louis in the 1870s. After the bridge was purchased by the St. Louis and San Francisco Railway in 1903, the name was changed to the Frisco Bridge.

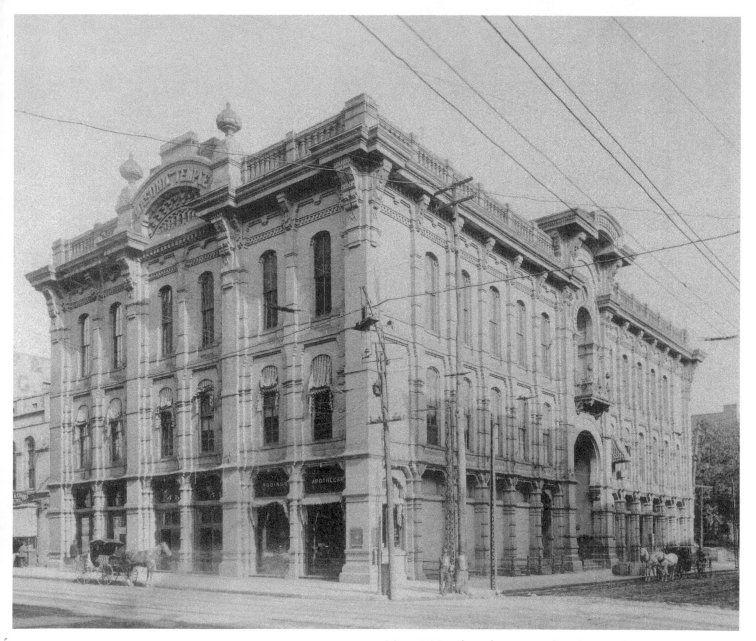

Masonic Temple at the corner of Madison and Second Street, 1895.

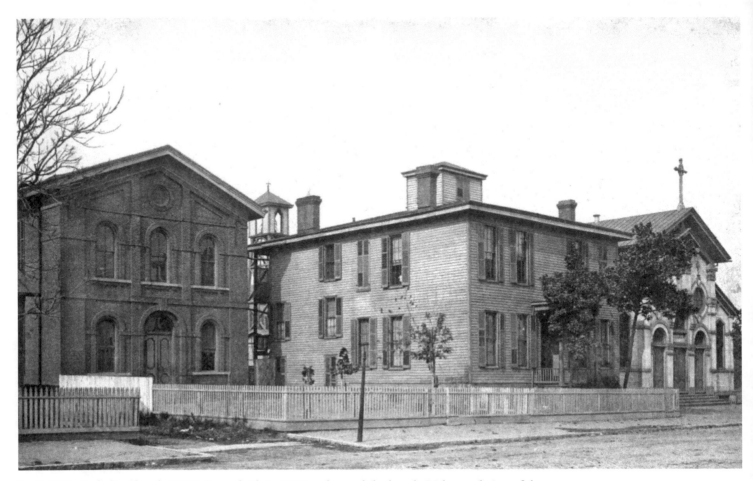

St. Brigid's Catholic Church, 1895. It was built in 1870 and served the largely Irish population of the Pinch District for many years.

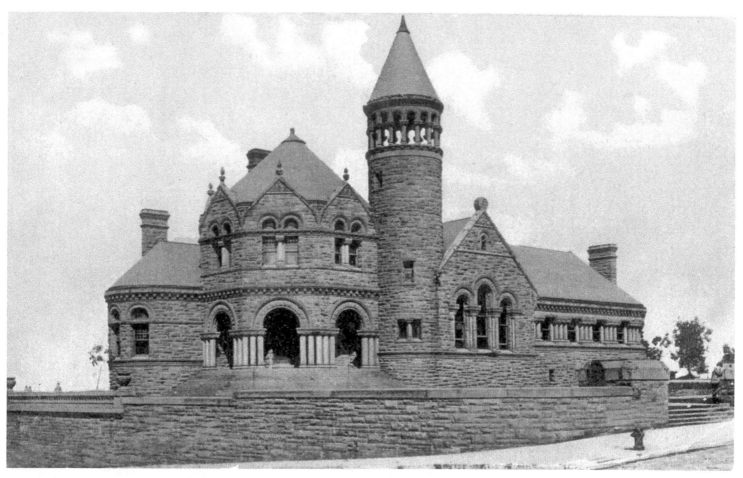

Cossitt Library, the city's first free public library, opened in 1893. It was financed by the heirs of dry goods magnate Frederick H. Cossitt. The original building featured a round tower and a triple-arched entry.

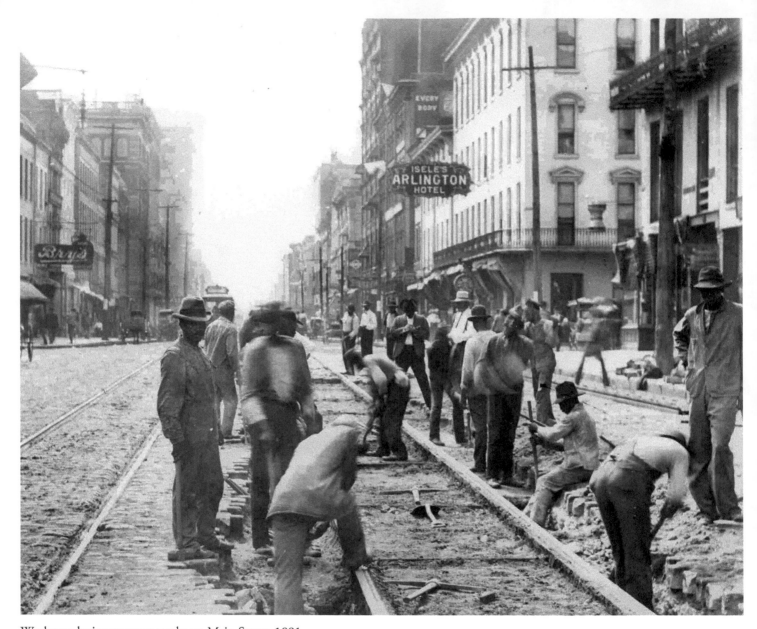

Workmen laying streetcar tracks on Main Street, 1891.

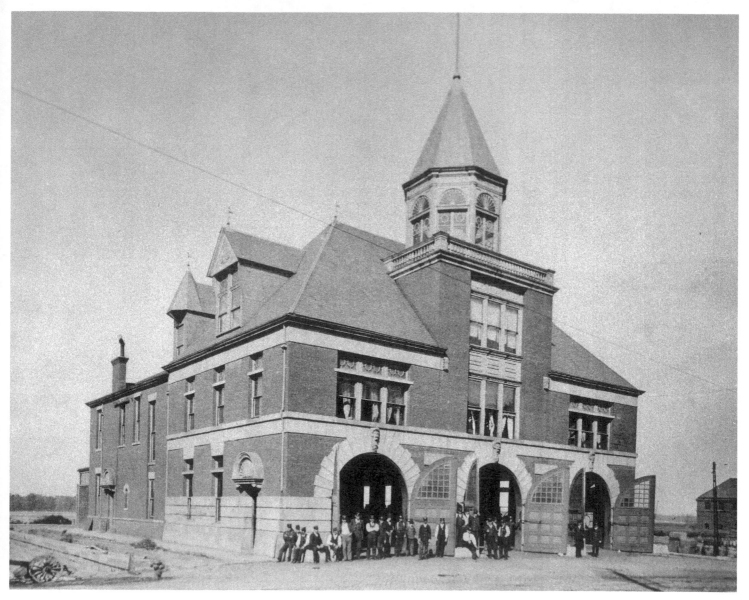

Fire Department Headquarters, 1895.

Cotton merchant Noland
Fontaine's mansion at 340 Adams.

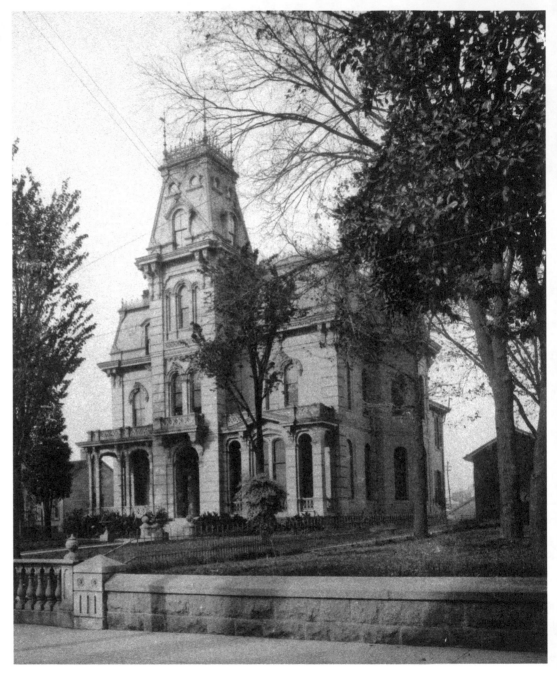

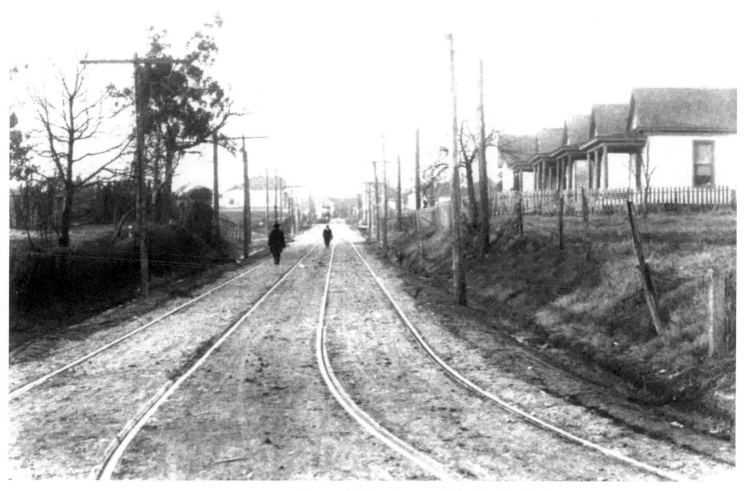

Scene on Latham Avenue at Trigg, looking north to McLemore Avenue, circa 1895.

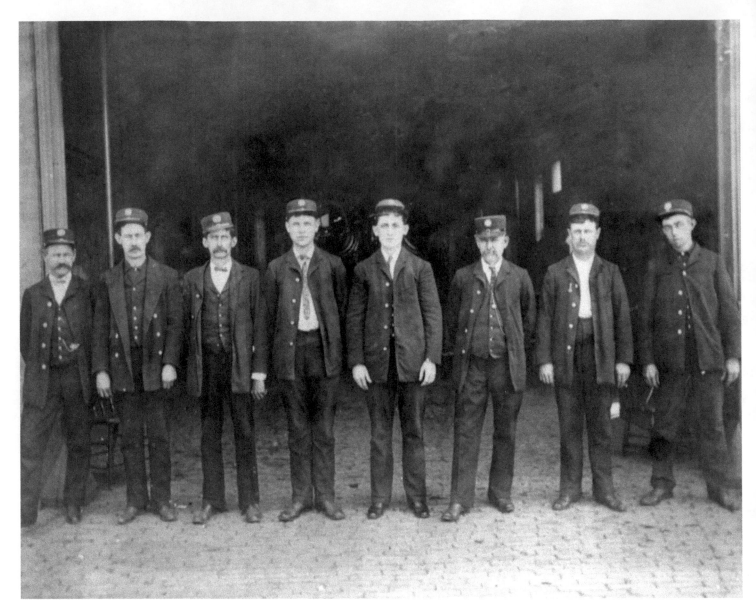

Memphis fire fighters, circa 1890.

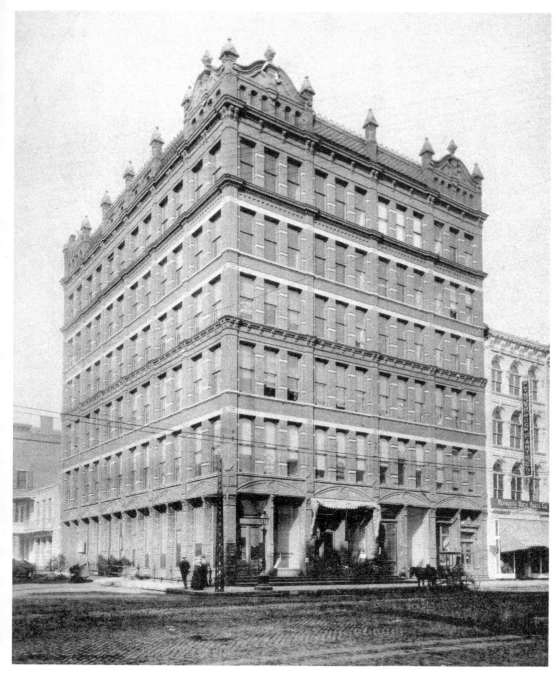

The Appeal Building, 1895. The building originally opened as the Collier Building in 1889, and in 1900 became the home of the Memphis newspaper the *Appeal*.

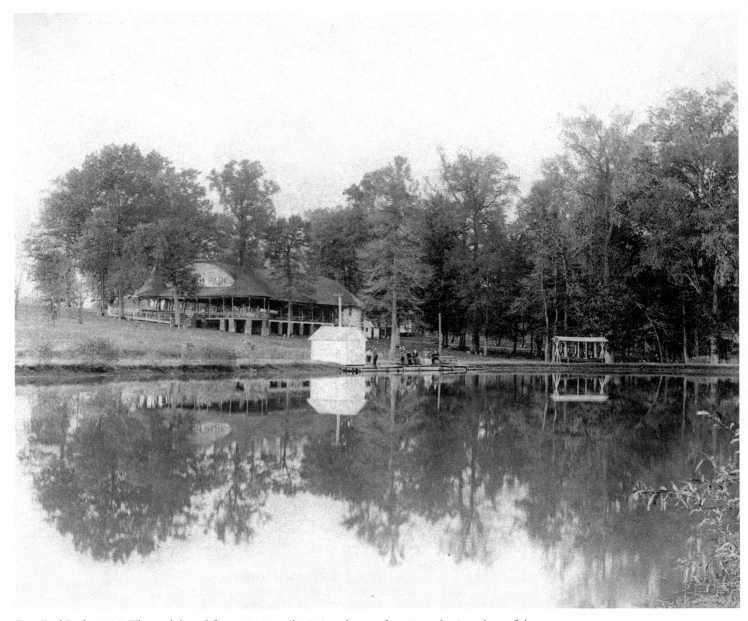

East End Park, 1895. The park lasted from 1889 until 1913 and was a favorite gathering place of the local German community.

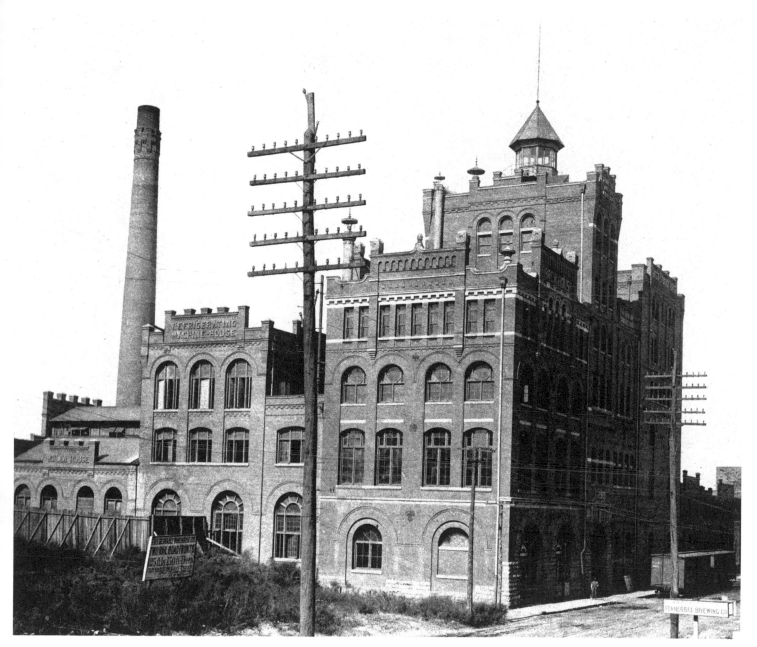

Tennessee Brewing Company at 477 Tennessee Street, 1895.

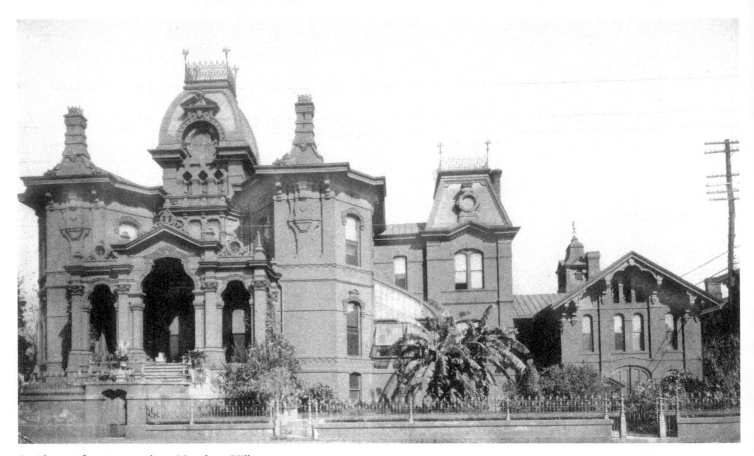

Residence of cotton merchant Napoleon Hill.

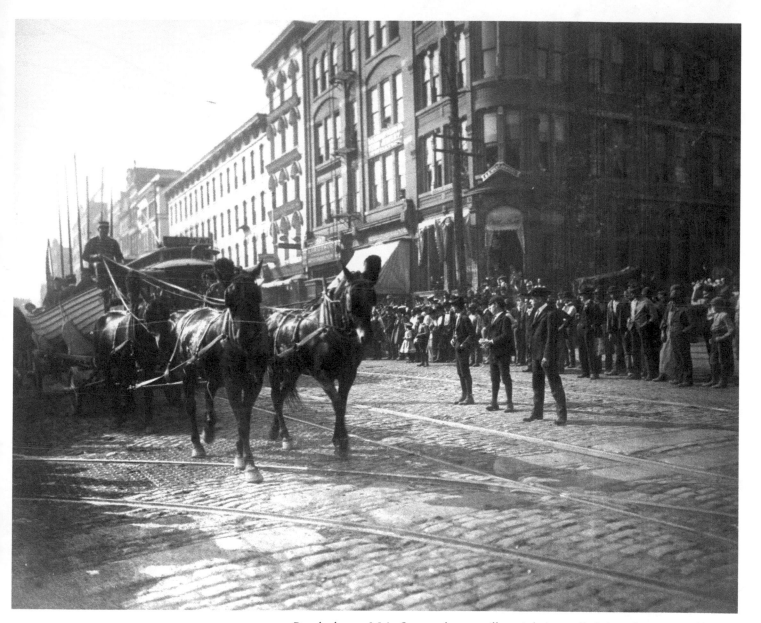

Parade day on Main Street, where a sailboat is being pulled along by a team of horses.

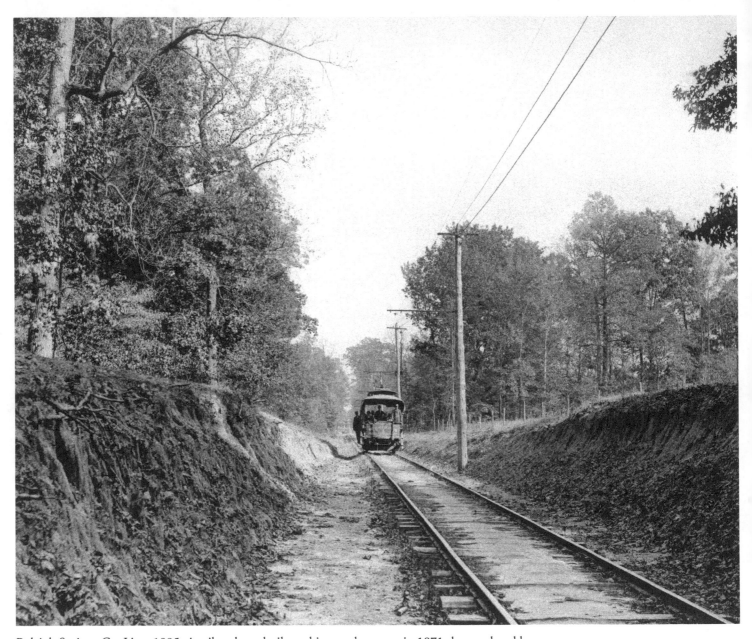

Raleigh Springs Car Line, 1895. A railroad was built to this popular resort in 1871 then replaced by an electric streetcar line in 1891.

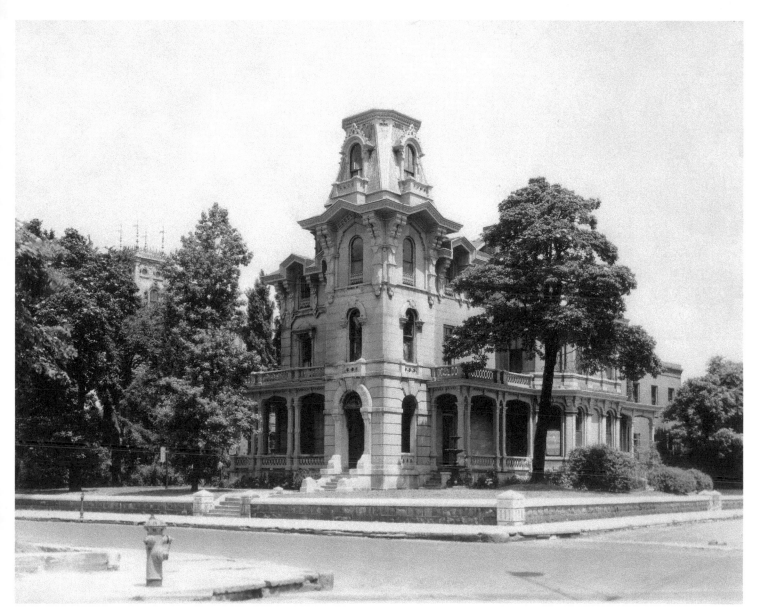

The James Lee House in Victorian Village.

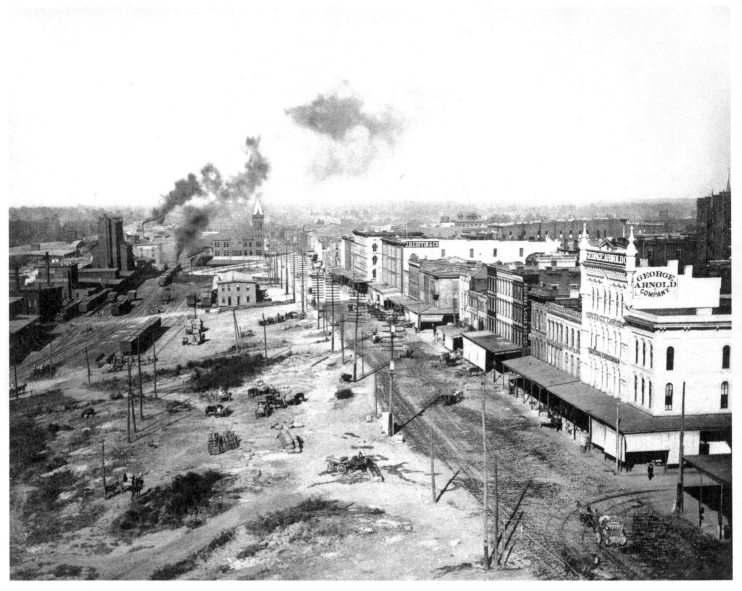

View of Front Street from the Government Building, circa 1895.

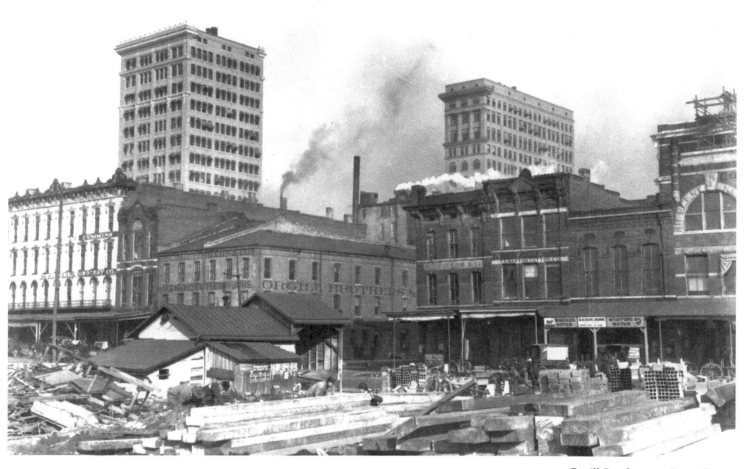

Orgill Brothers on Front Street.

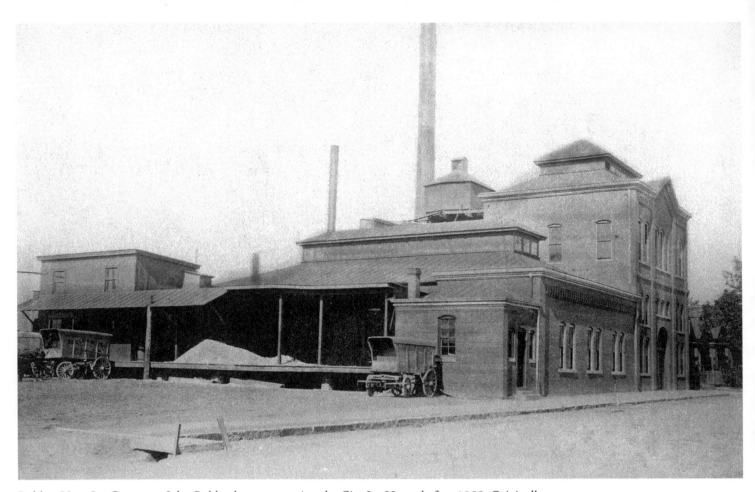

Bohlen-Huse Ice Company. John Bohlen began operating the City Ice House before 1855. Originally, ice was cut from frozen northern lakes and stored in the company's underground ice houses. Later, artificial means were used to produce ice from local artesian water.

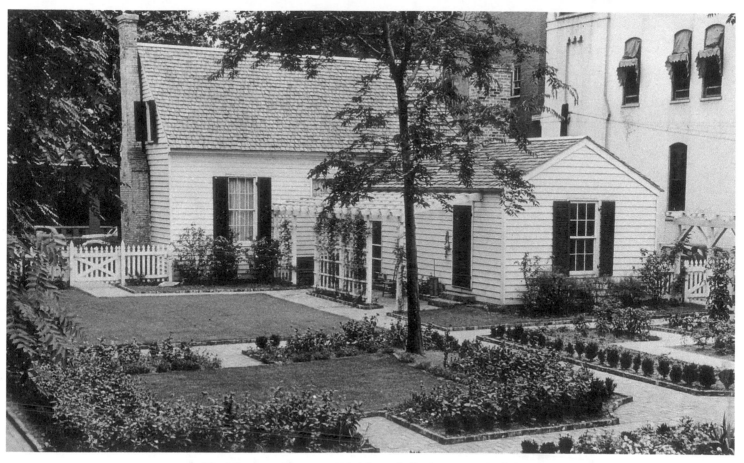

The Magevney House at 198 Adams, built circa 1833. Irish-born Eugene Magevney was a teacher and real estate entrepreneur. His home was the site of the first Catholic Mass, Marriage, and Baptism in Memphis.

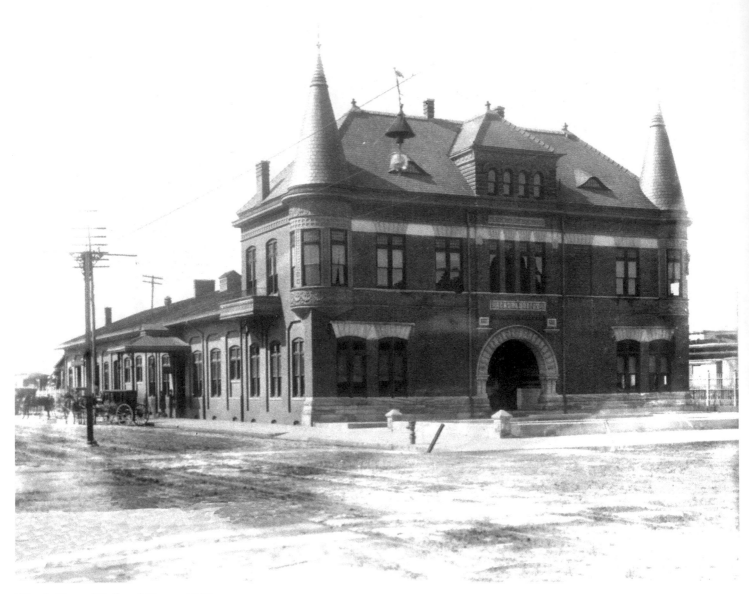

Illinois Central Railroad Depot, 1899.

Union Avenue in 1895.

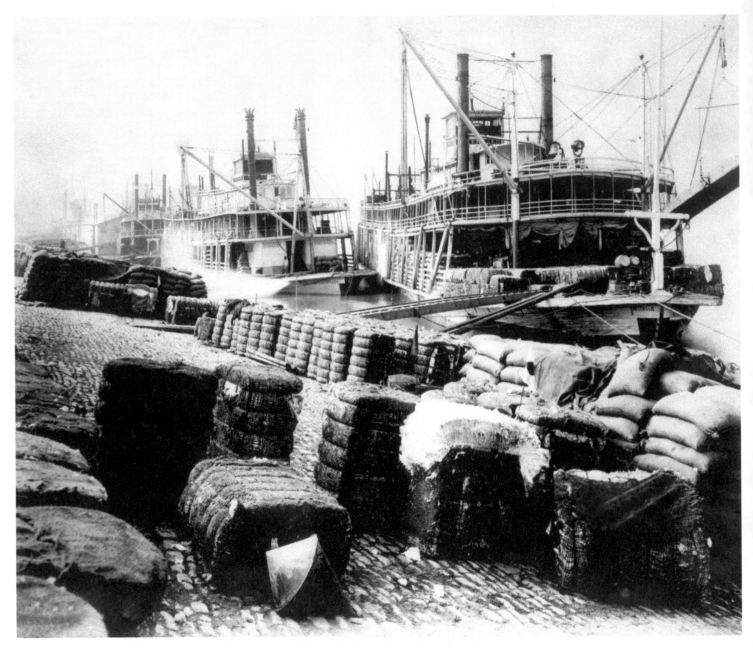

The *Peters Lee* shipped freight between Cincinnati and Memphis from 1904 through 1913.

THE TWENTIETH CENTURY DAWNS

(1900–1919)

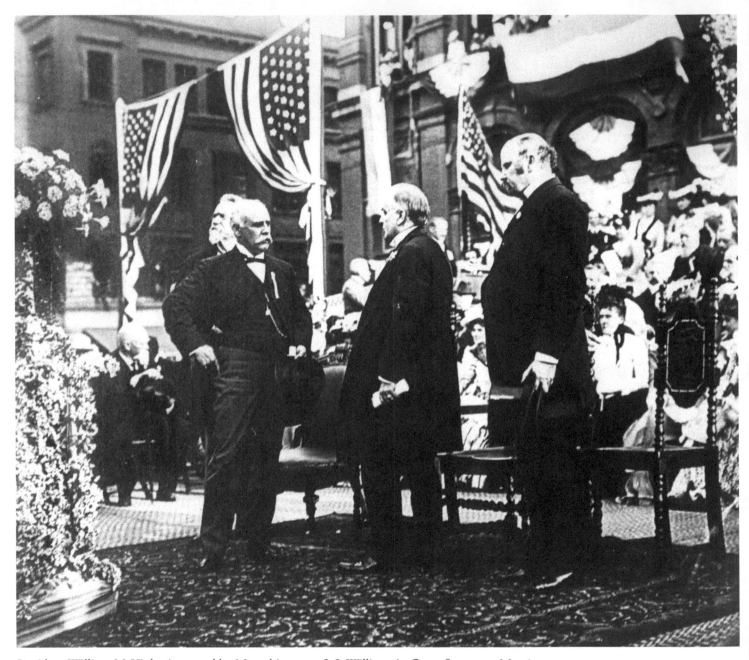

President William McKinley is greeted by Memphis mayor J. J. Williams in Court Square on May 1, 1901.

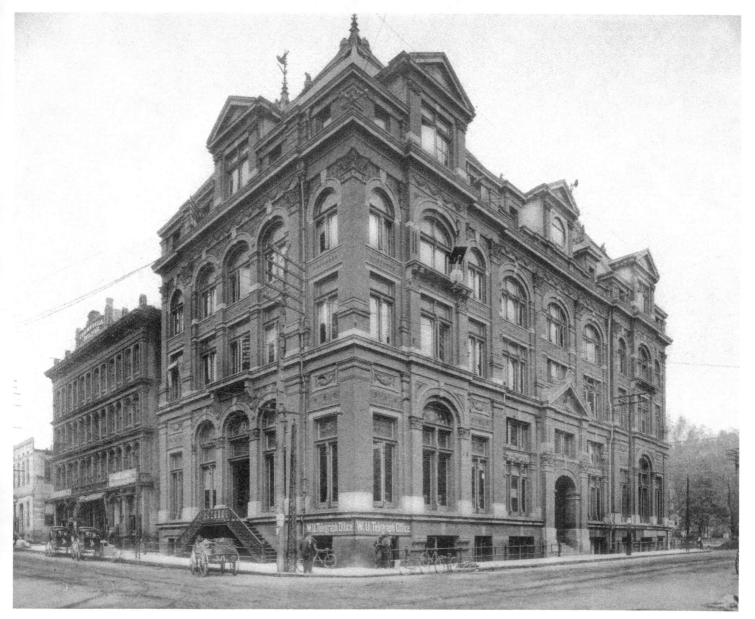

The Cotton Exchange Building at the corner of Madison and Second, 1900.

At the turn of the century,
Memphis prided itself as the
"hardwood capital of the world."

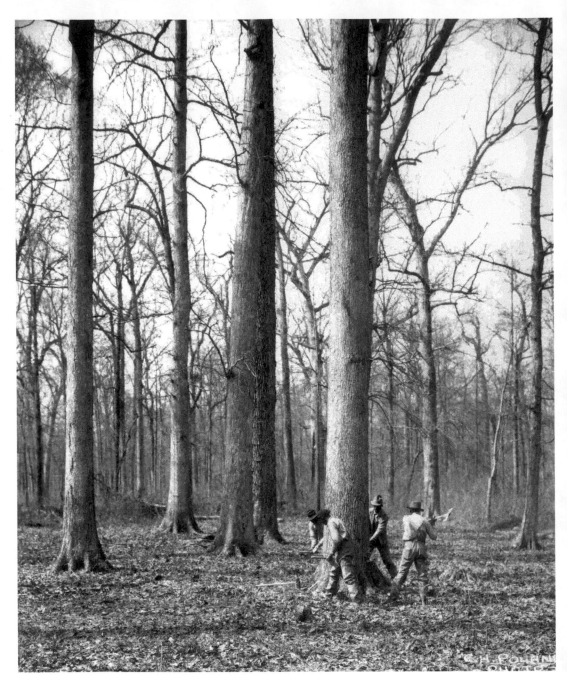

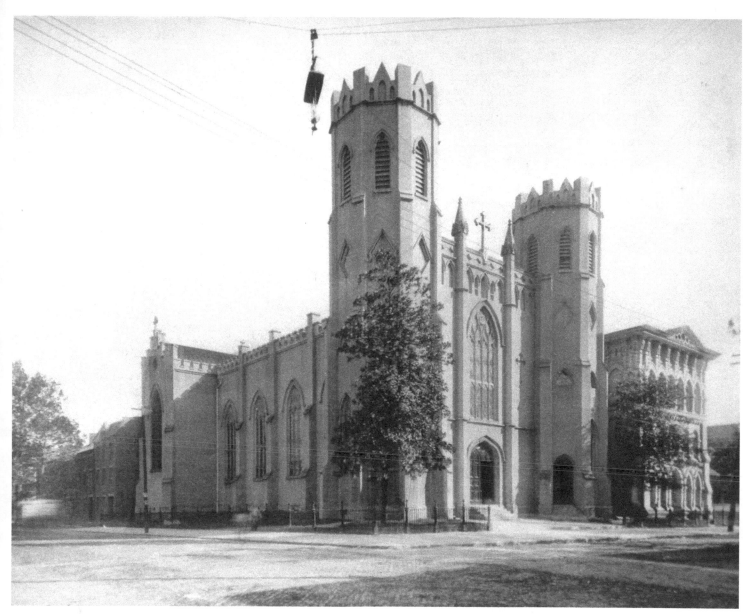

St. Peter's Catholic Church, 1900. Completed in 1855, this was the first Catholic Church in Memphis.

Interior of St. Peter's Catholic Church.

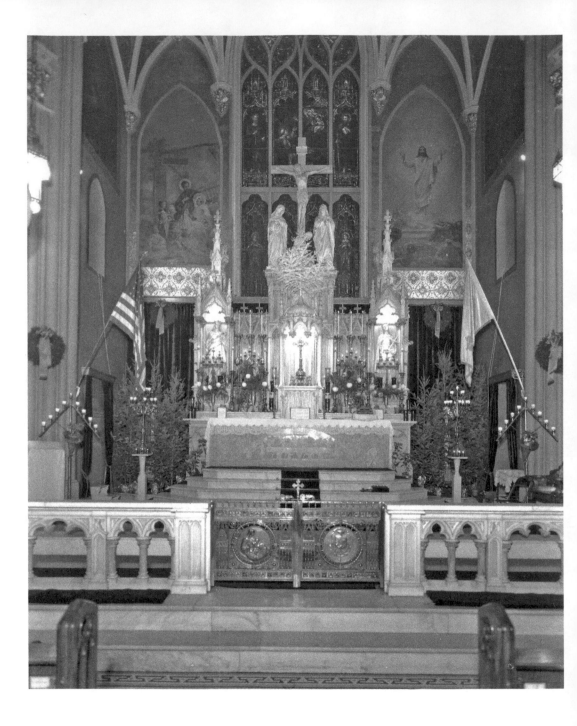

Scene from Raleigh Springs Resort, 1902. Its natural spring water made it a popular destination for Memphians.

Raleigh Springs Resort, 1900.

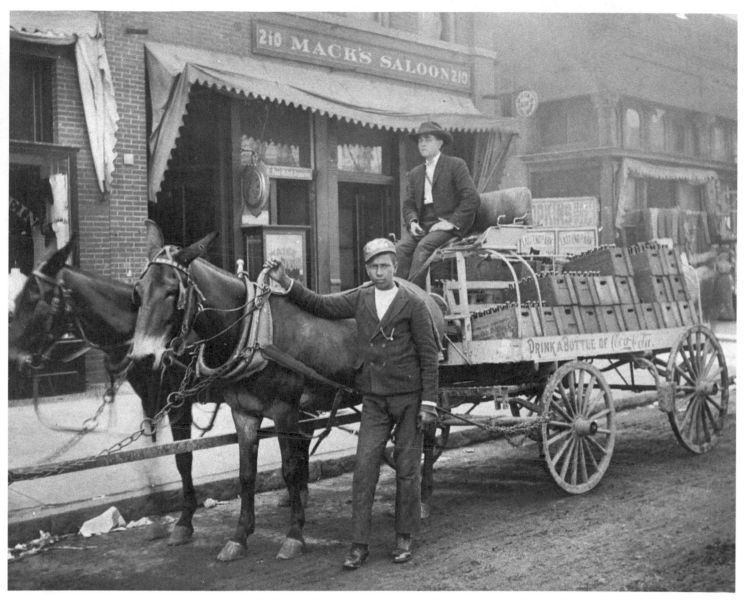

A mule-drawn Coca-Cola wagon driven by Landan Smith. Mack's Saloon, which was operated by Charles McClelland, appears in the background.

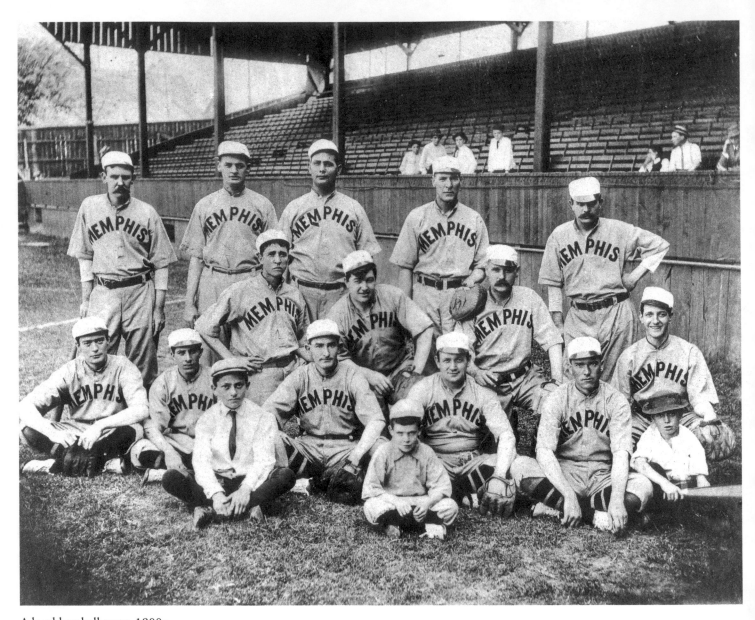

A local baseball team, 1900s.

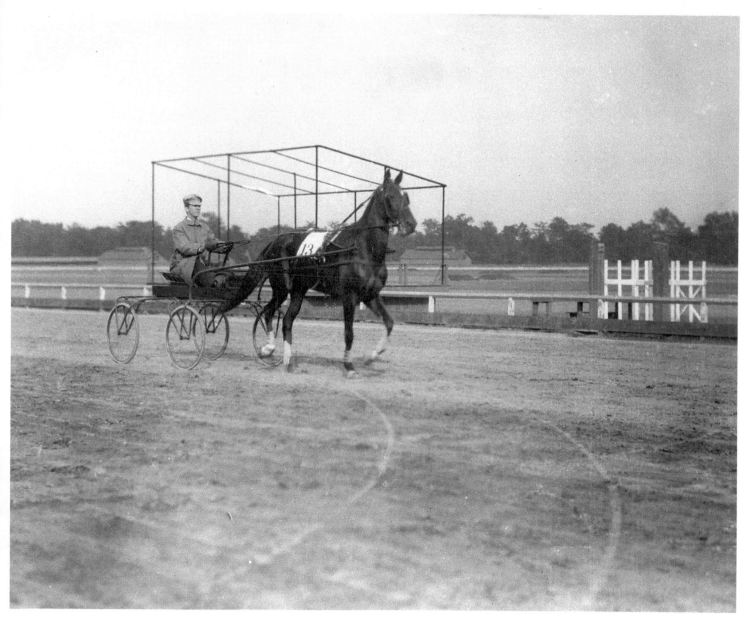

Harness racing at Montgomery Park, circa 1900.

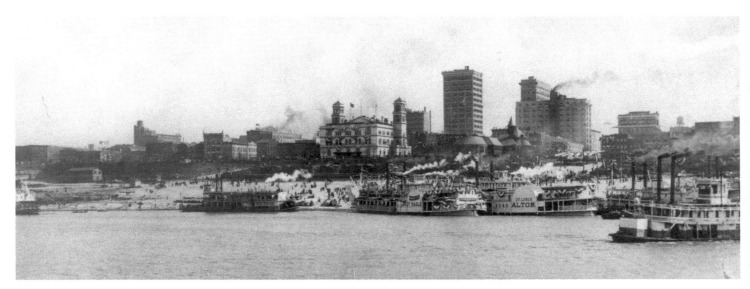

The steamboats *Grey Eagle* and *Alton* docked at the waterfront at Memphis, 1909.

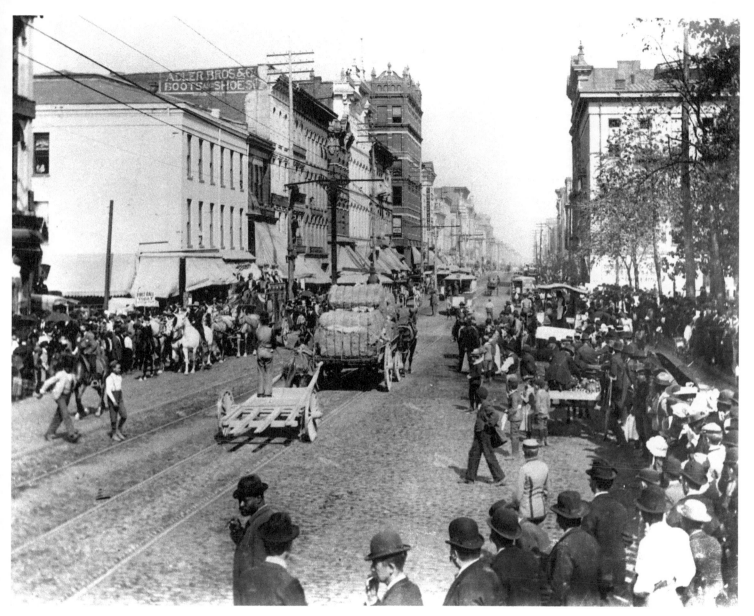

Scene on Main Street near Court Square.

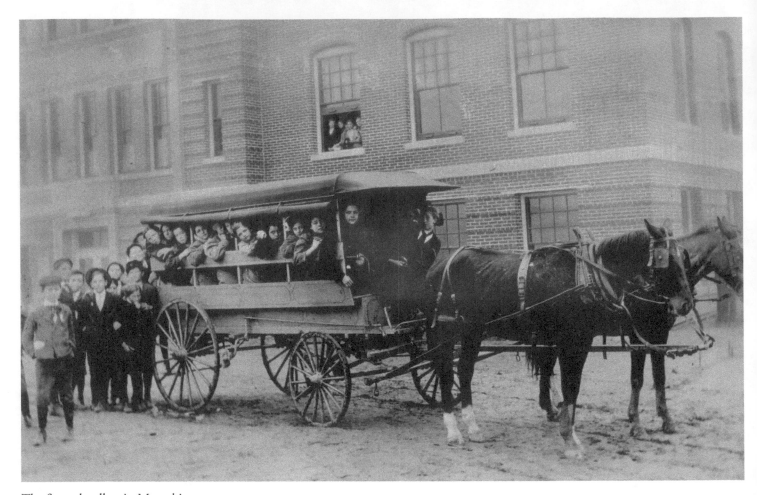

The first schoolbus in Memphis.

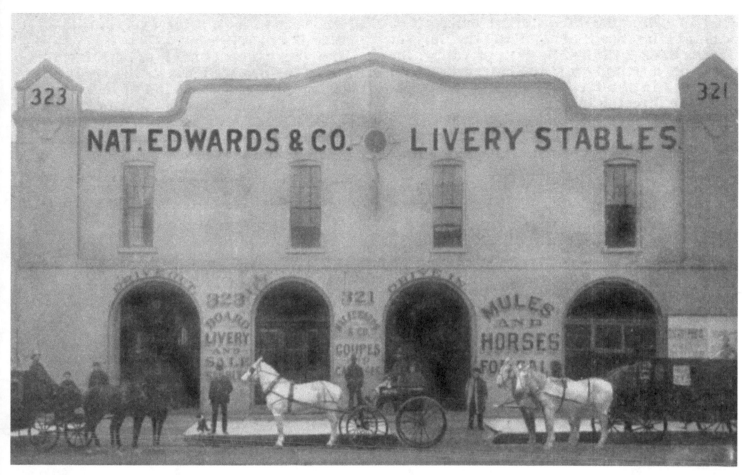

Nat Edwards and Company Livery Stables.

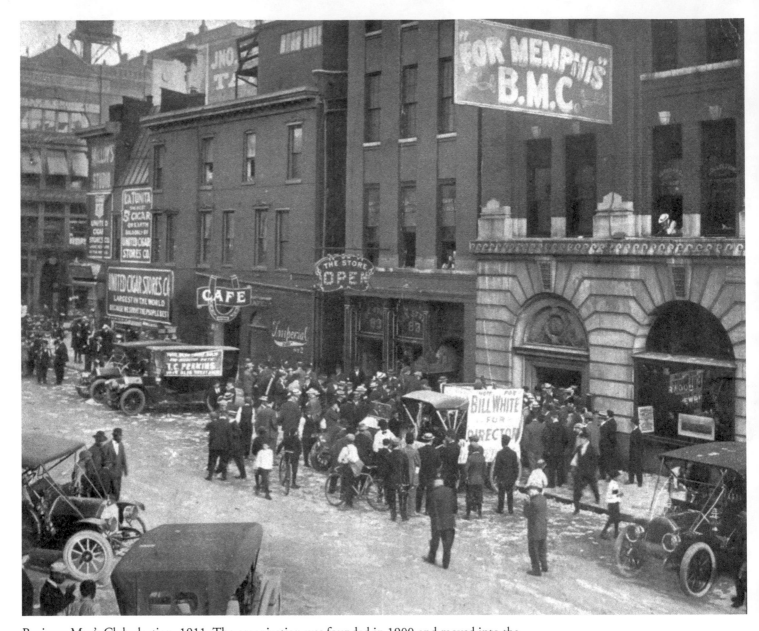

Business Men's Club election, 1911. The organization was founded in 1900 and moved into the building pictured at 81 Monroe in 1907. Beginning in 1913, the building was the headquarters for the Memphis Chamber of Commerce.

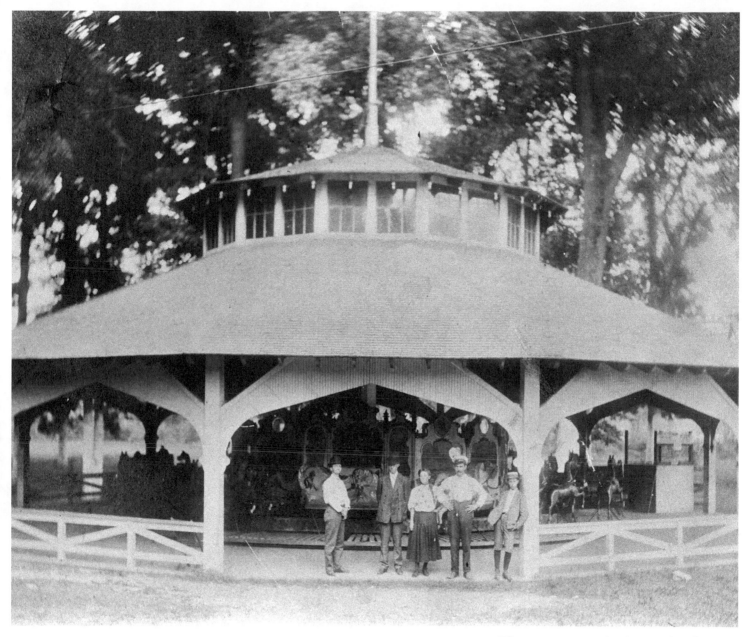

The merry-go-round at East End Park, 1911.

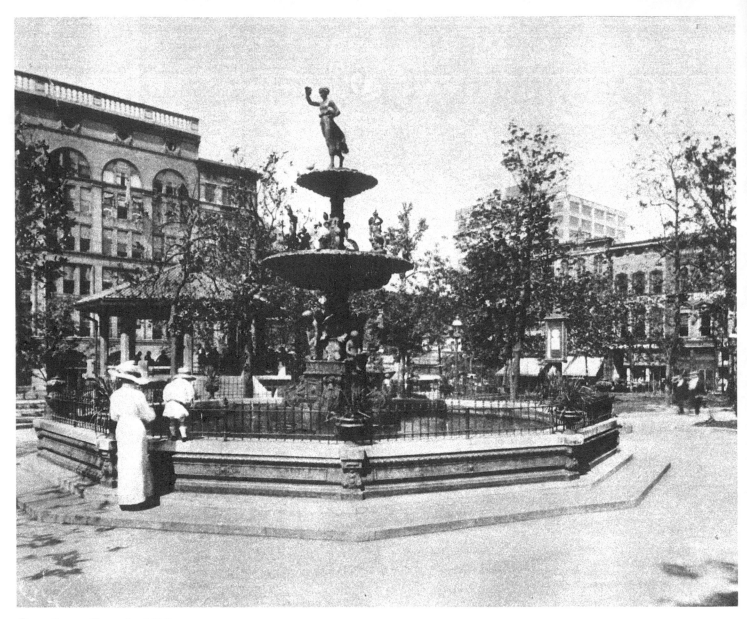

Court Square Fountain, 1912.

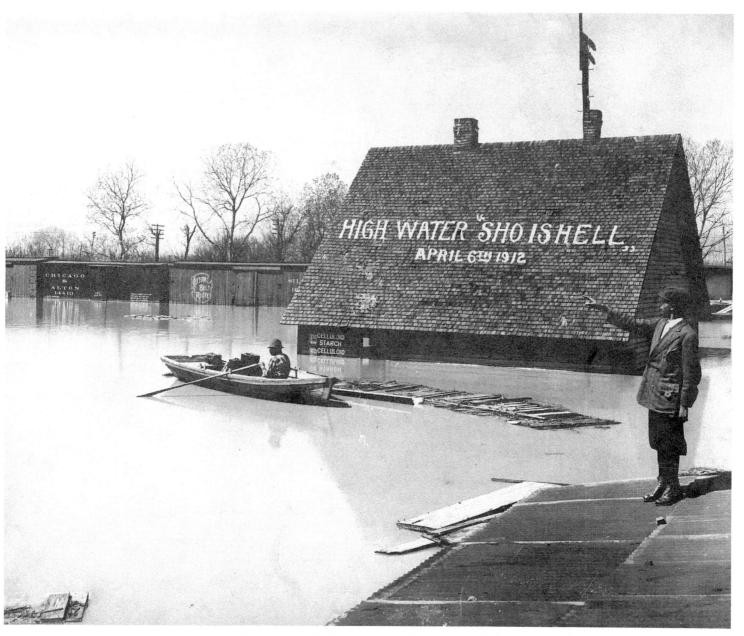

Scene from the 1912 Mississippi River flood. Memphis was relatively safe from high water, but some low-lying areas in the city became susceptible to rising back water as flood levels worsened at the beginning of the twentieth century.

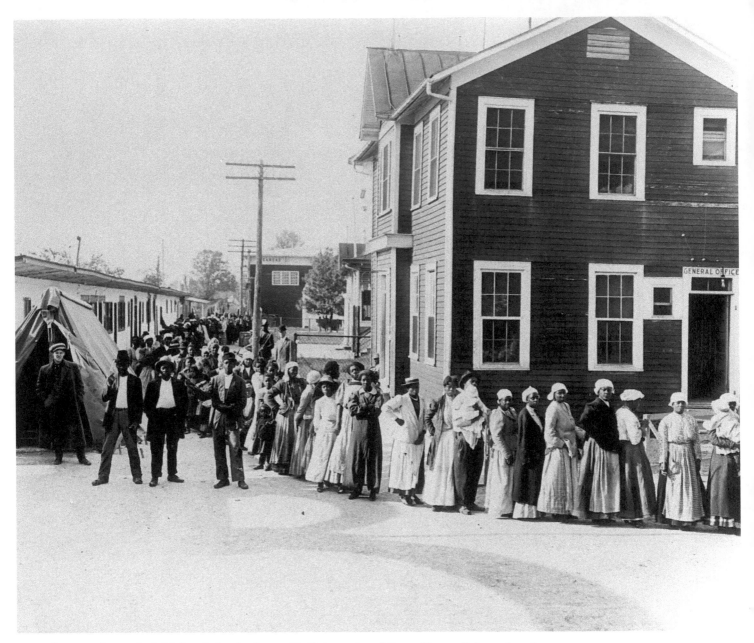

Memphis was a haven for Mid-South flood refugees. Facilities such as "Camp Crump," shown here in 1912, were set up in the city to house refugees.

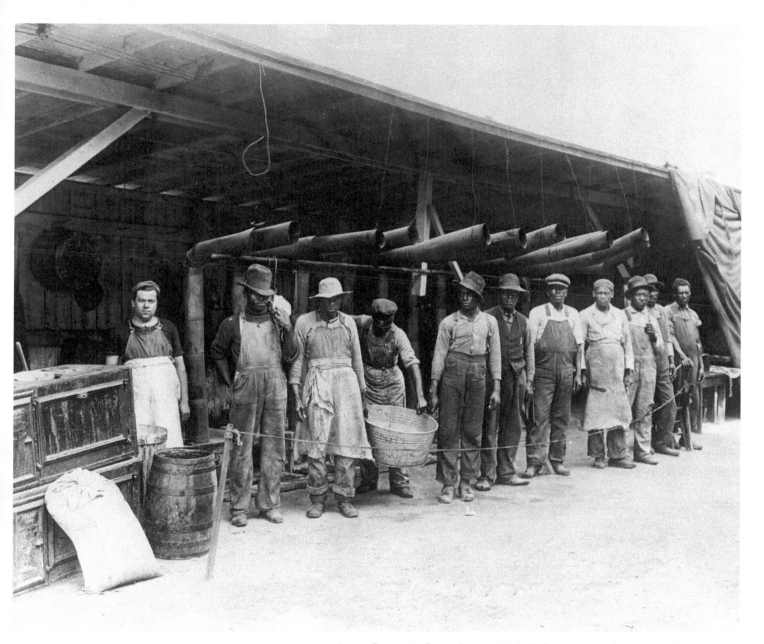

Camp Crump Refugee Camp, 1912. Refugees were often required to perform manual labor in return for assistance.

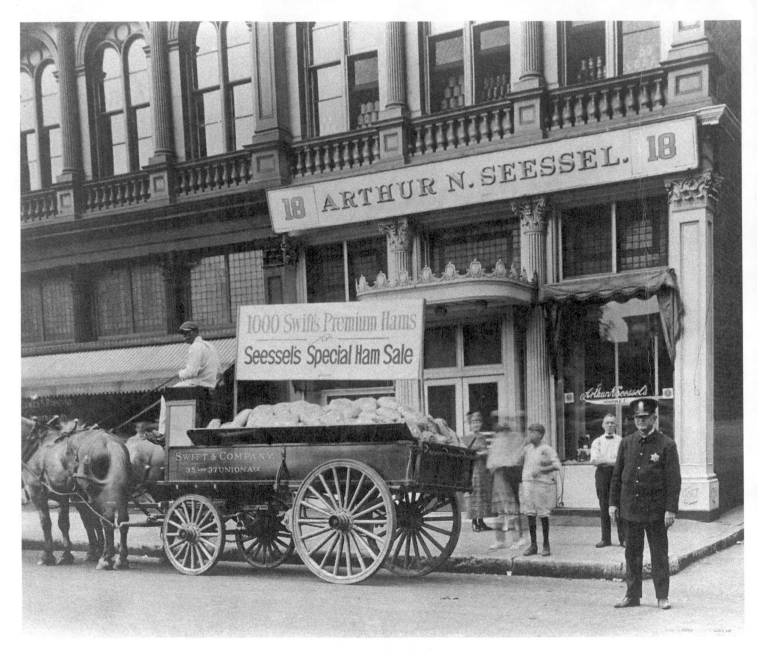

German-born Henry Seessel arrived in Memphis in 1857 and began a butcher business. In 1917, his grandson Arthur opened a full-line grocery, pictured here at 18 North Second. The Seessel family owned a chain of grocery stores which lasted until 2002.

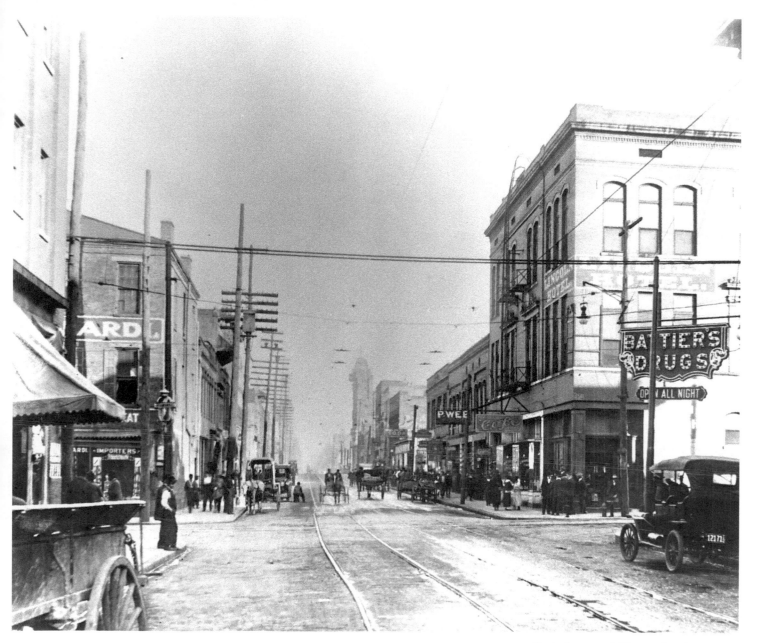

Beale Street and Hernando, circa 1915.

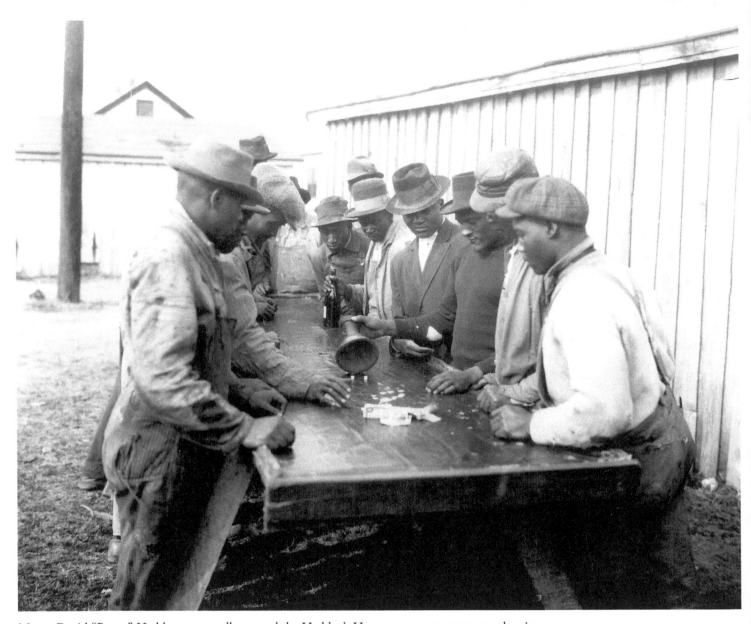

Mayor David "Pappy" Hadden supposedly created the Hadden's Horn as a way to ensure no cheating when throwing dice.

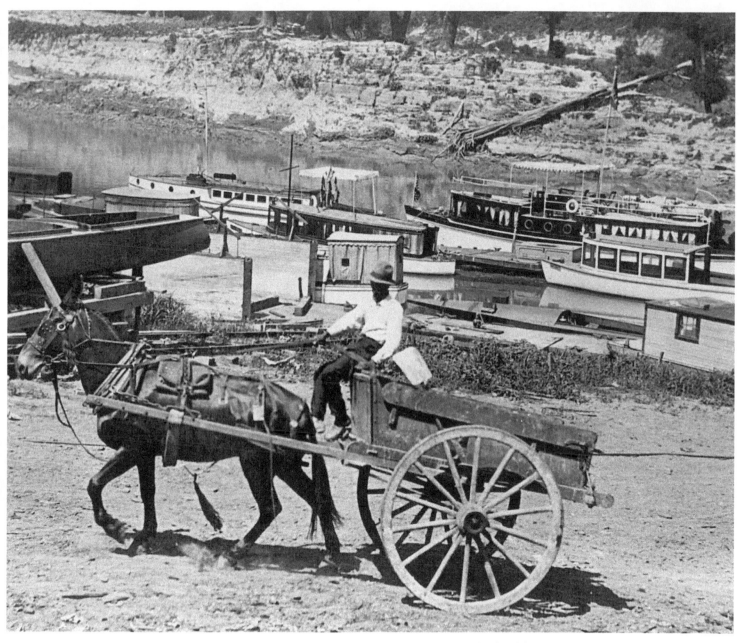

Scene on the bank of the Wolf River at the Gayoso Oil Works.

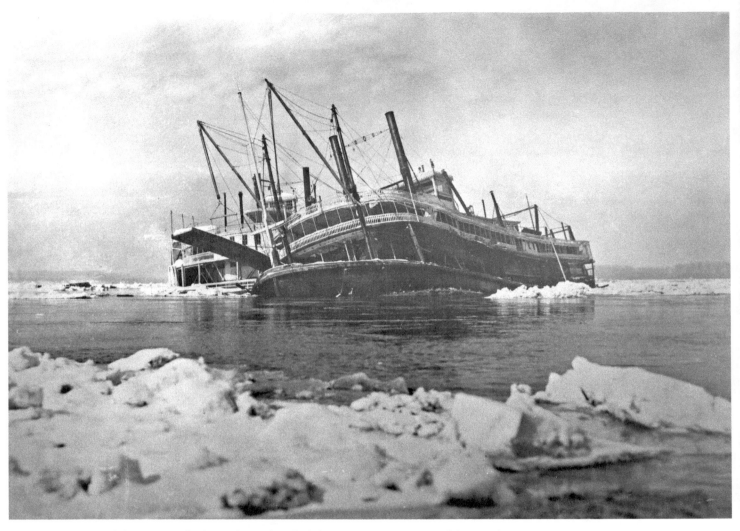

The *Georgia Lee* and the *Desoto*, which was formerly called the *James Lee,* were two of the vessels destroyed when the Mississippi River froze in January 1918.

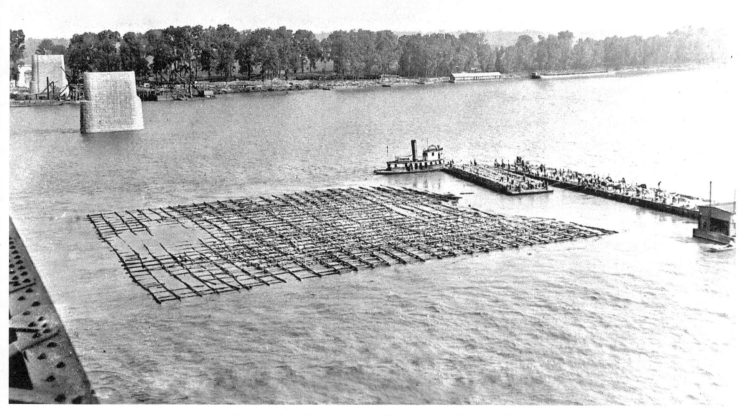

Mats such as the one pictured here were used to stabilize the river bed for the construction of the Harahan Bridge in 1914.

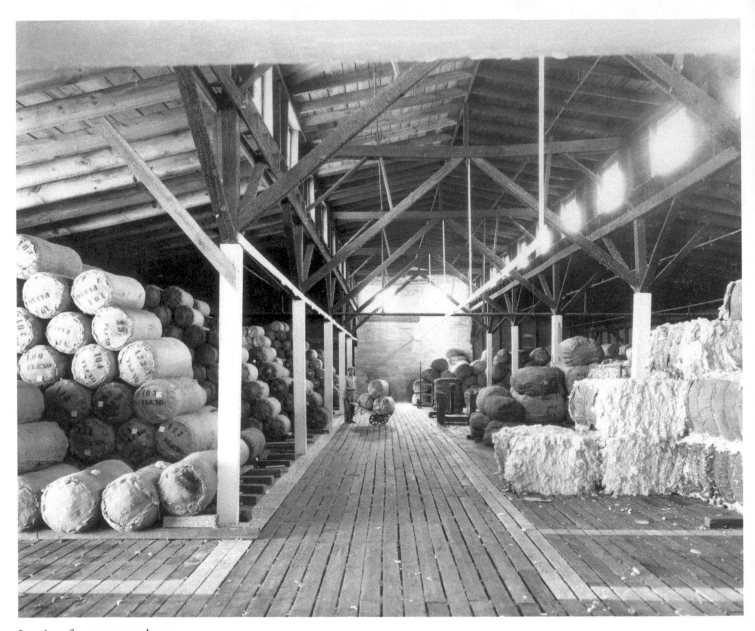

Interior of a cotton warehouse.

Thriving Metropolis

(1920–1939)

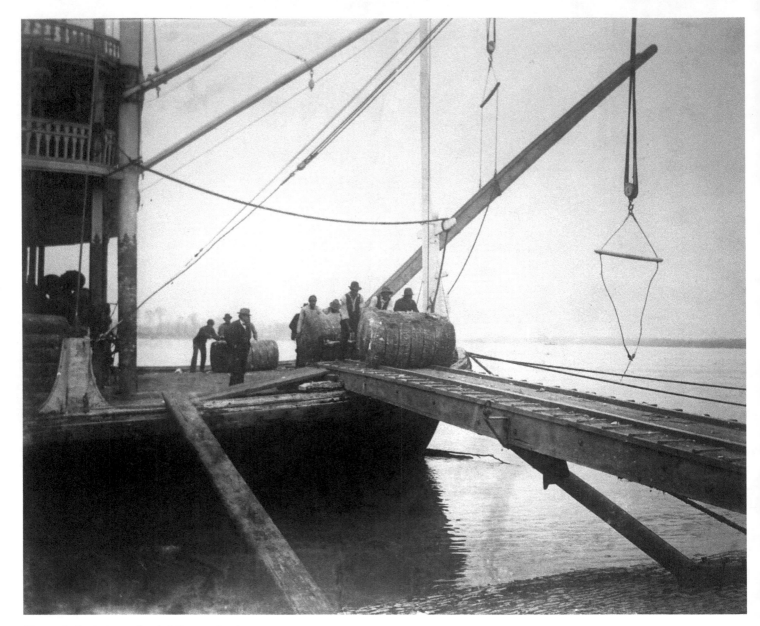

Cotton bales being unloaded from a riverboat.

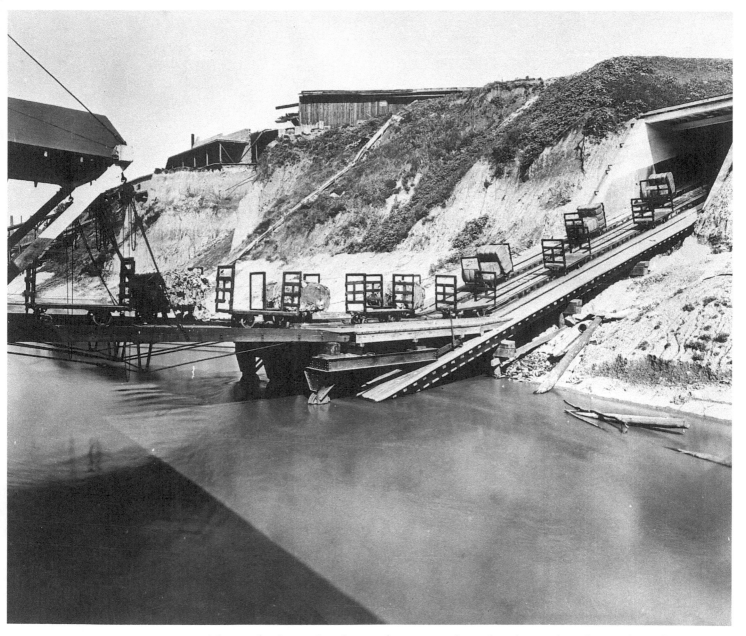

Thousands of tons of products such as cotton, charcoal, and canned goods were shipped by barge on the Mississippi River by the Federal Barge Line through the Port of Memphis.

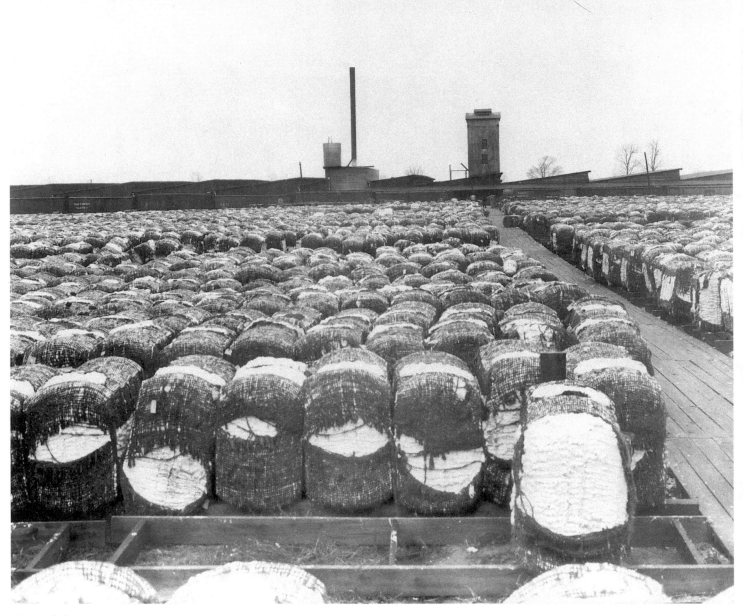

Cotton bales.

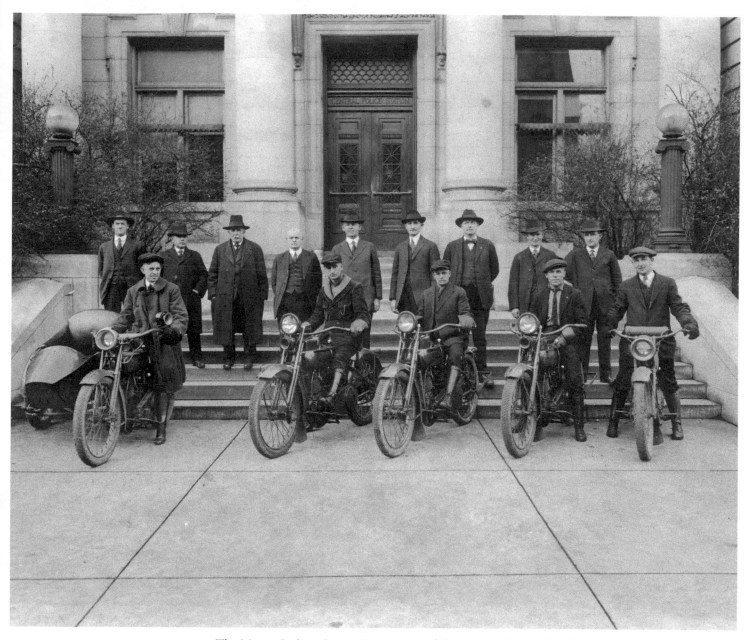

The Motor Cycle and Auto Department of the Metropolitan Police Department pictured in front of the Central Police Station, 1920.

Clarence Saunders, the founder of Piggly Wiggly. Saunders founded his business with one store in 1916, and by 1922, the chain had grown to include more than 1,200 stores nationwide.

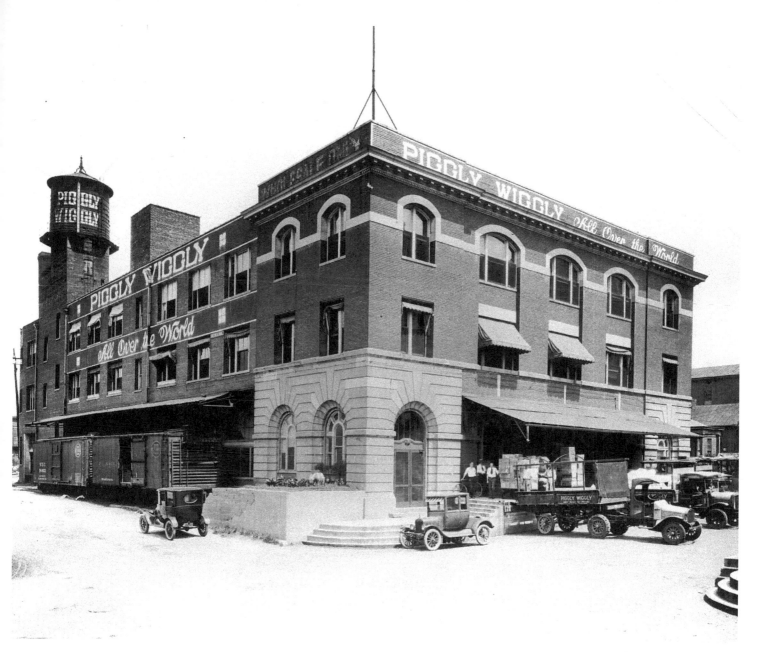

Piggly Wiggly warehouse.

The Pink Palace was originally the home of Clarence Saunders. The city came into possession of the property after Saunders lost his fortune, and it was turned into a museum in 1930.

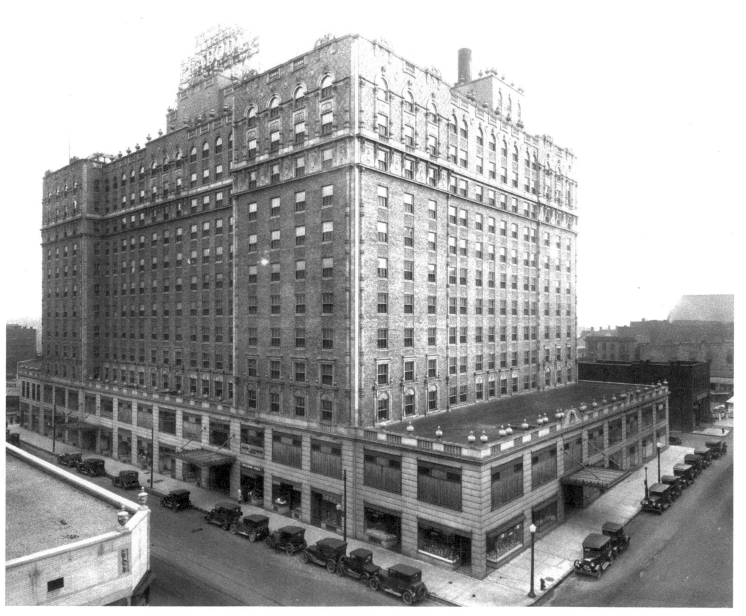

The current incarnation of the Peabody Hotel opened at 149 Union Avenue in 1925.

The Peabody Hotel lobby features a Bernini-inspired fountain occupied by live ducks who are escorted from their rooftop roost every morning.

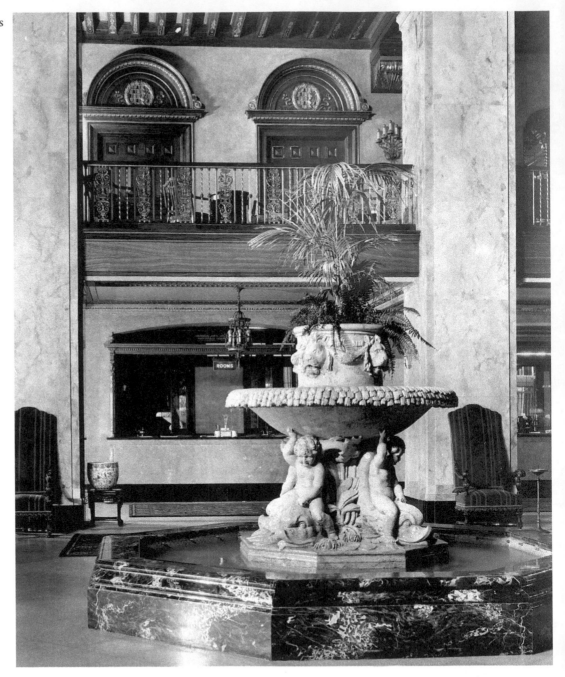

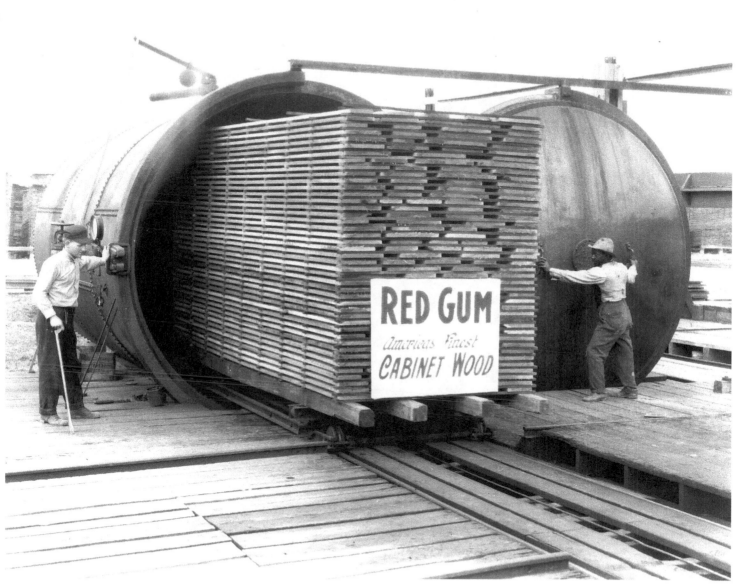

Kilns at the Fisher-Hurd Lumber Company.

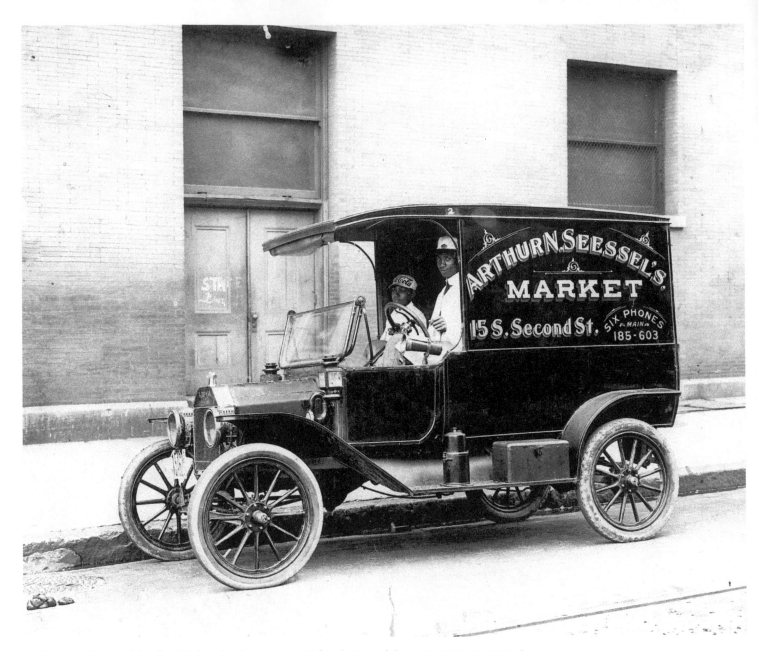

Arthur Seessel moved his family's butcher business to 15 South Second Street in 1909. In 1912, he began using gasoline-powered trucks to deliver his goods. Seessel's grocery stores continued to deliver items to customers' homes until 1965.

A typical cotton gin where cotton was processed and packaged.

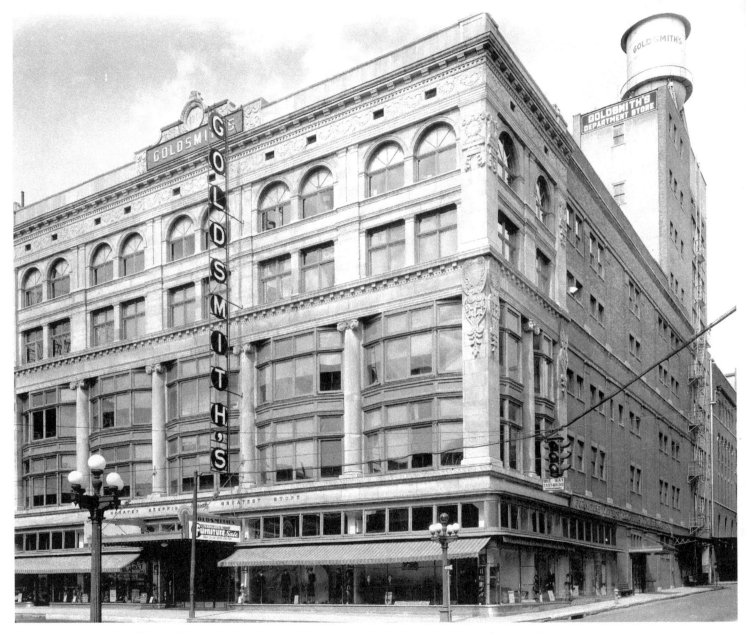

German-born Jacob and Isaac Goldsmith bought their first store on Beale Street in 1870 and a second on Main in 1881. In 1901, Jacob moved operations into this building at 123 South Main after Isaac's death.

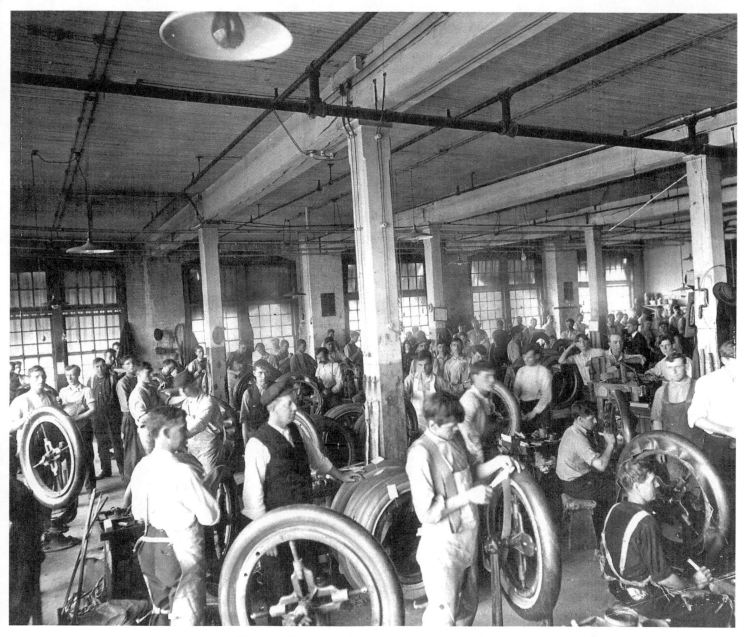

Firestone Tire and Rubber Company made its first tire on January 19, 1937. The 85-acre North Memphis facility operated until 1983.

The Medical Arts Building was built in 1924. It was purchased in 1952 and renamed the Hickman Building by *Cotton Trade Journal* president Francis Hickman and his sister Jane Hickman.

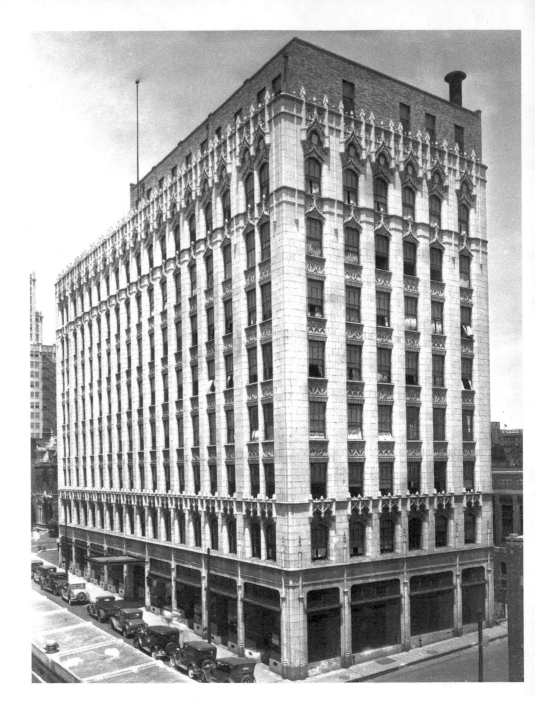

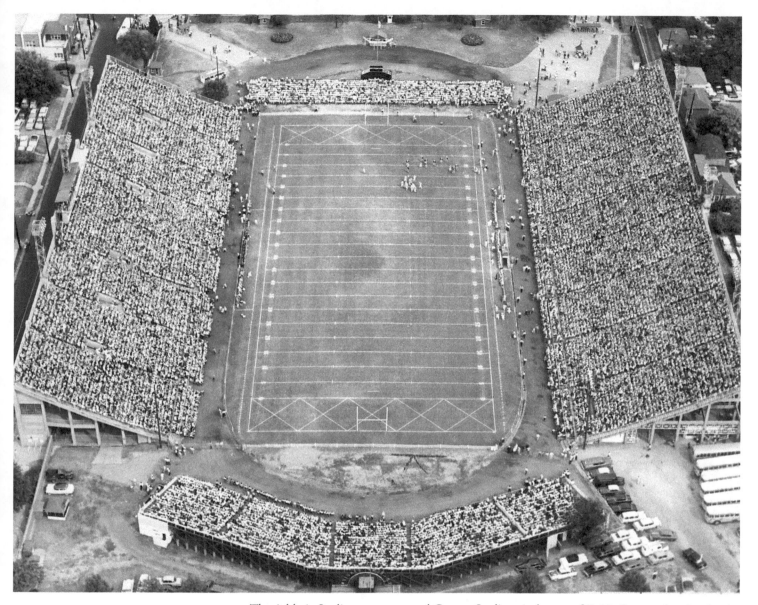

The Athletic Stadium was renamed Crump Stadium in honor of E. H. Crump shortly after its completion in 1934.

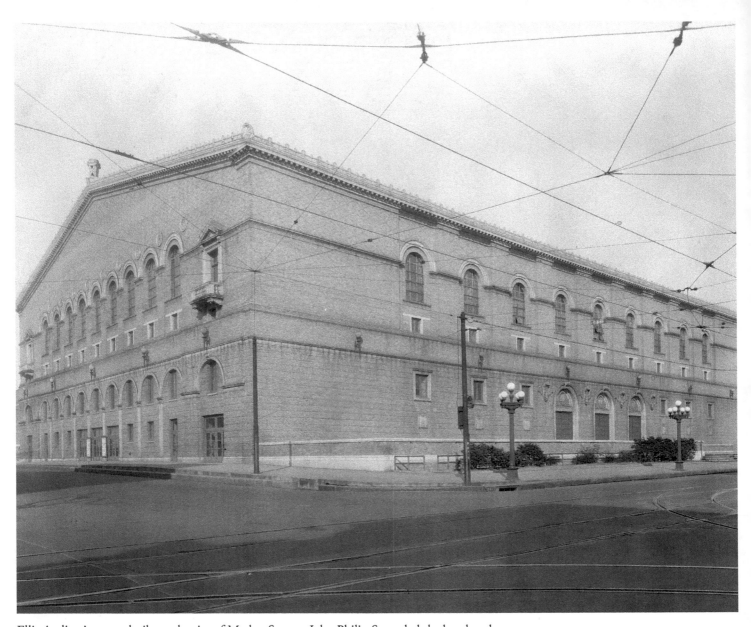

Ellis Auditorium was built on the site of Market Square. John Philip Sousa led the band at the opening ceremony on October 17, 1924. The final performance there was given by Bruce Springsteen on November 19, 1996.

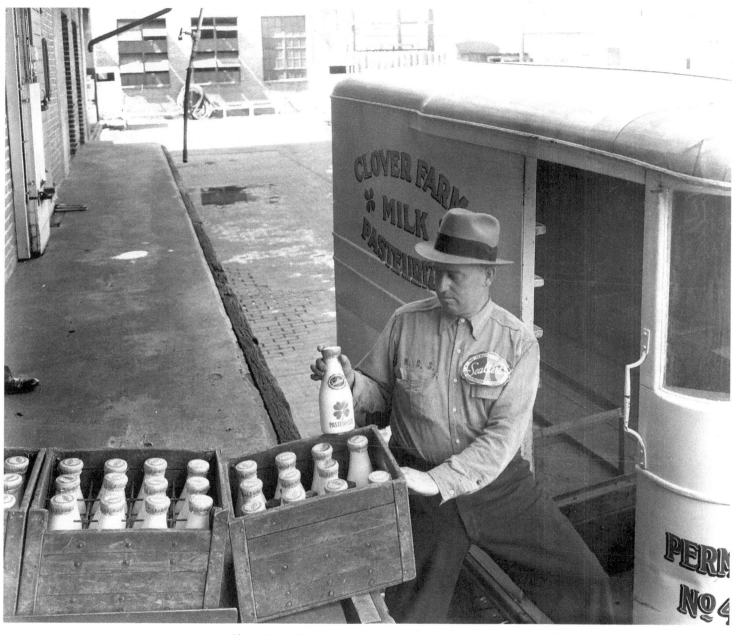

Clover Farm Dairy Company traced its origins back to Major Thompson's 1871 dairy farm. The Memphis Pure Milk Company bought the operation in 1905 and pioneered local efforts in dairy pasteurization and refrigeration.

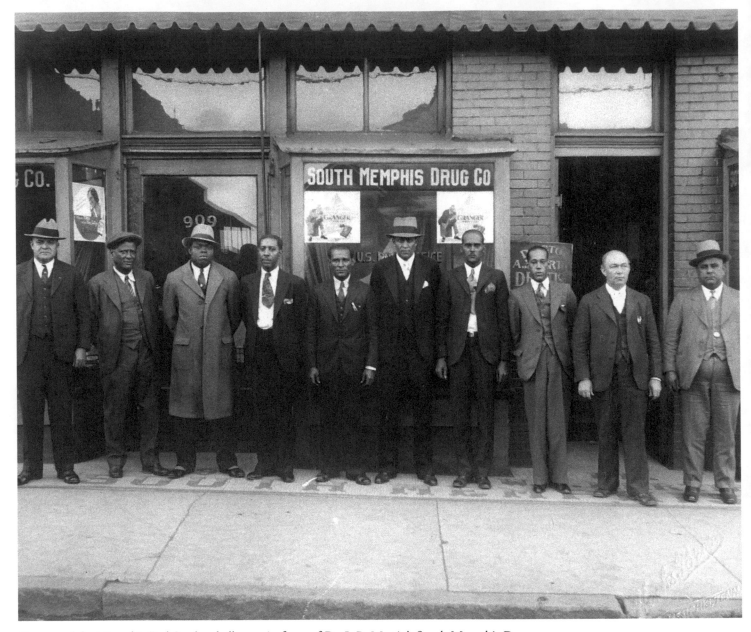

Owners of the Memphis Red Sox baseball team in front of Dr. J. B. Martin's South Memphis Drug
Company on Florida Street.

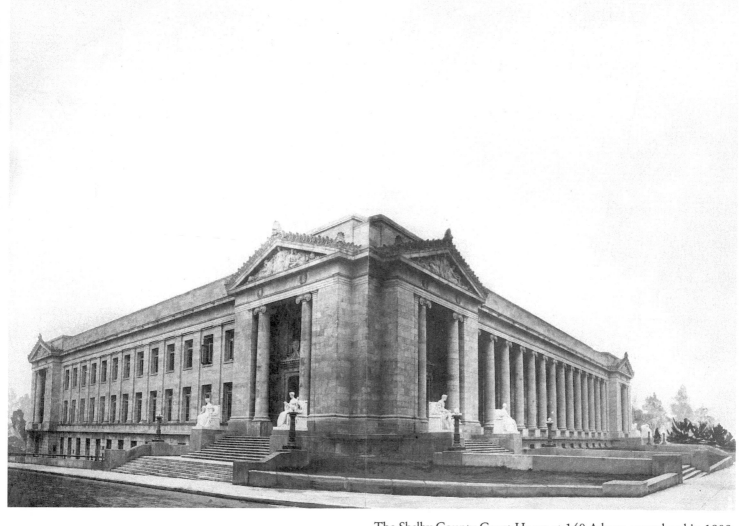

The Shelby County Court House at 140 Adams, completed in 1909.

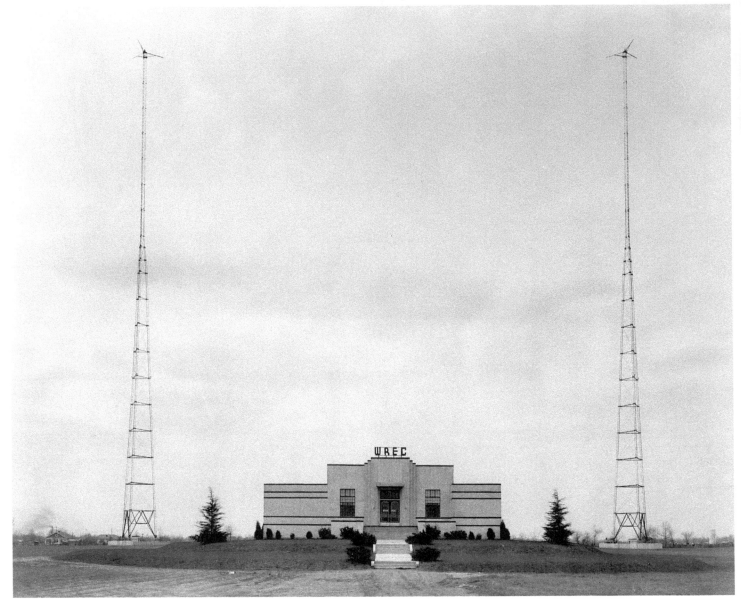

WREC Radio Station at Payne Avenue and Hindman Ferry Avenue, circa 1936.

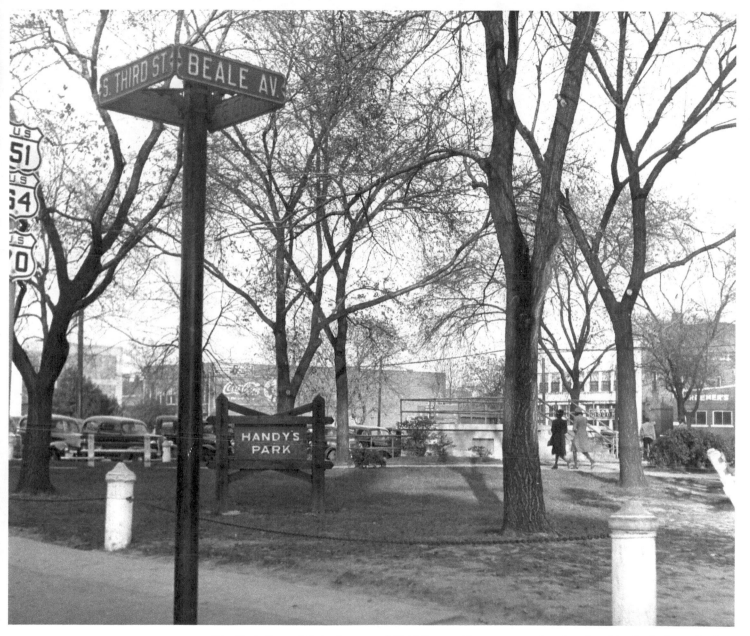

The Beale Street Markethouse and Cold Storage Plant was razed and replaced by Beale Street Park in 1930. In 1931, the park was renamed Handy's Park in honor of the famous composer W. C. Handy.

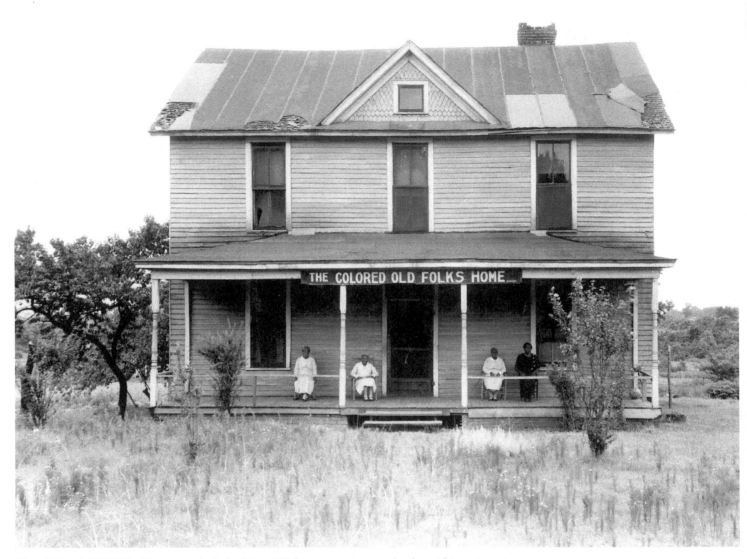

The Colored Old Folks Home was built by Dave Washington, who was the first African-American Memphian appointed to the U.S. Postal Service.

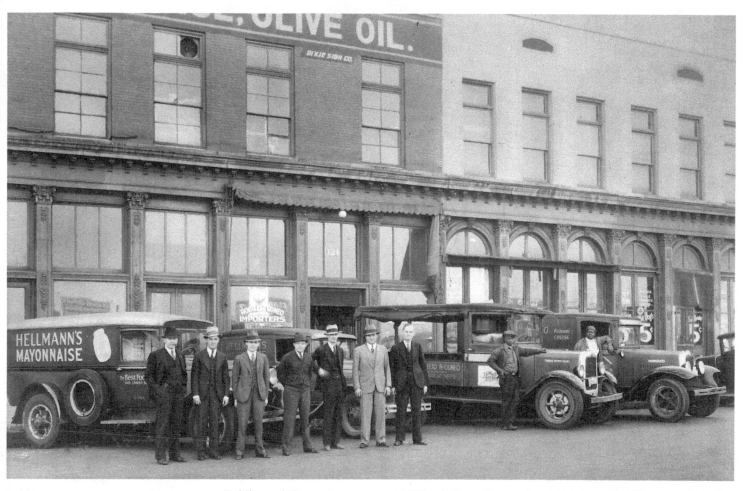

Robilio and Cuneo Importers at 124 North Front Street, circa 1931. John Robilio opened his first grocery store at Jackson and Alabama in 1909, two years after arriving from Italy. He partnered with Thomas Cuneo in 1929 to form Ronco, a pasta manufacturer and import business.

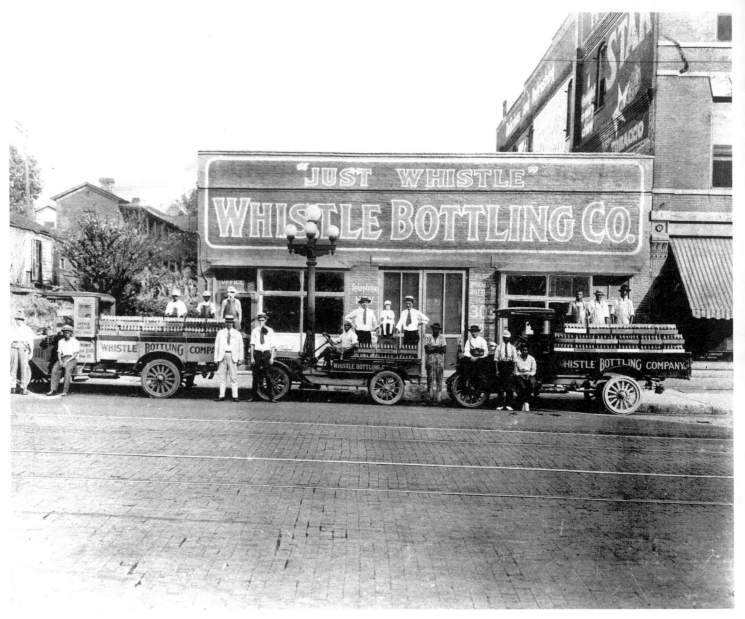

Whistle Bottling Company at 303-307 South Main.

Scene from Court Square, 1932.

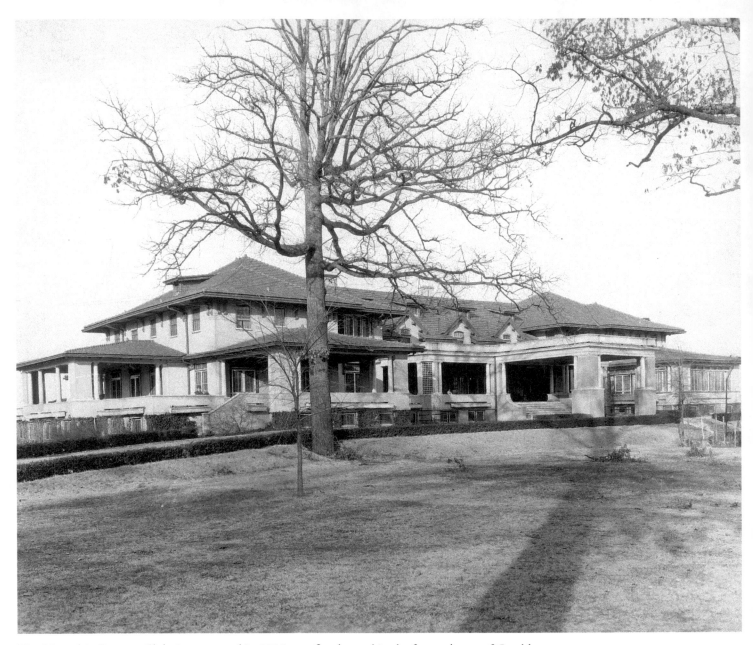

The Memphis Country Club, incorporated in 1905, was first located in the former home of Geraldus Buntyn. The second club building, pictured here, was built after the first burned in 1910. This facility was demolished and replaced with a new building in 1958.

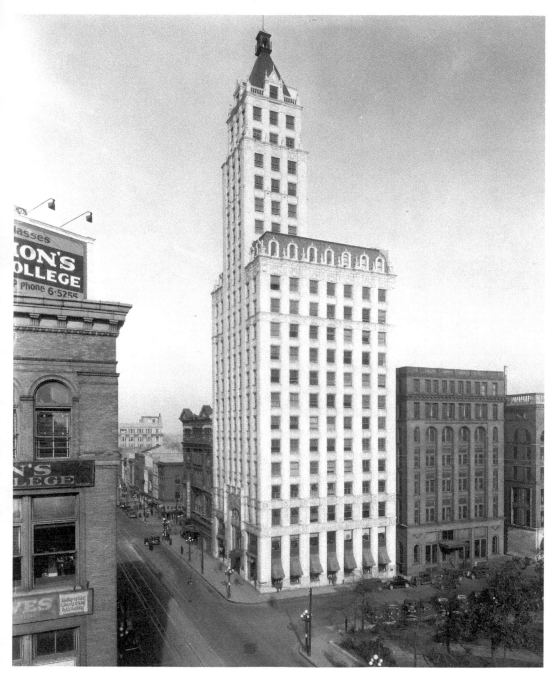

The Columbia Mutual Tower, later named the Lincoln-America Tower, 1935.

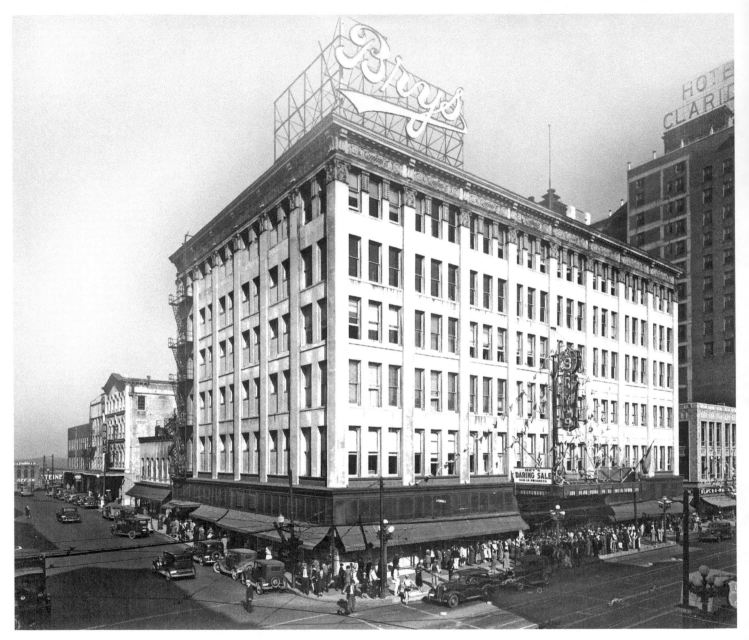

Bry's Department Store, 1936.

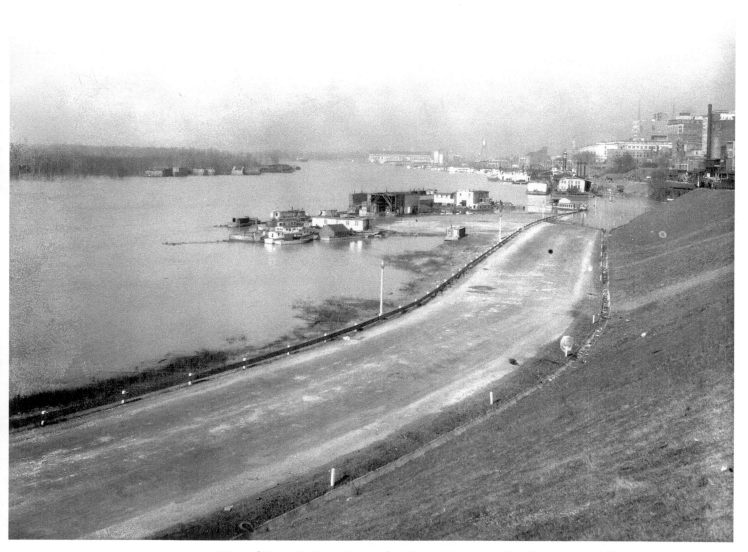

View of Riverside Drive during the Ohio-Mississippi Valley flood of 1937. Water covered Riverside where it meets Beale Street.

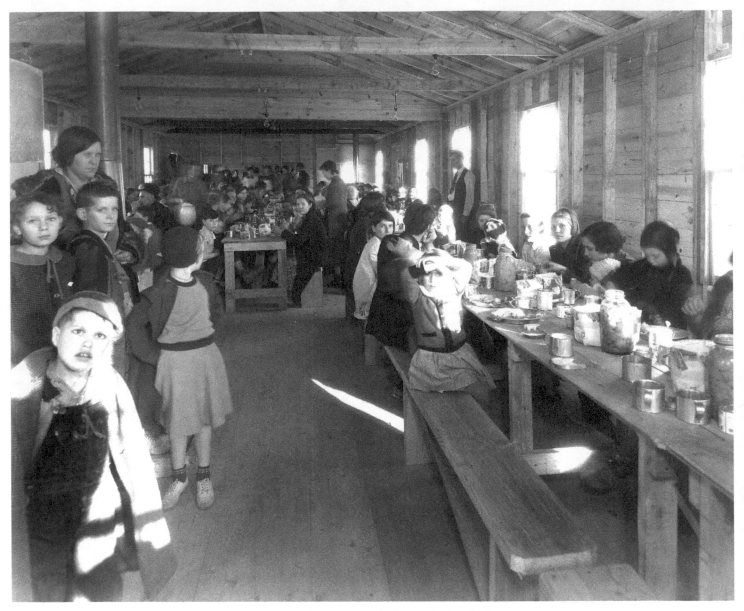

A view of the mess hall at the makeshift refugee camp at the Fairgrounds during the flood of 1937.

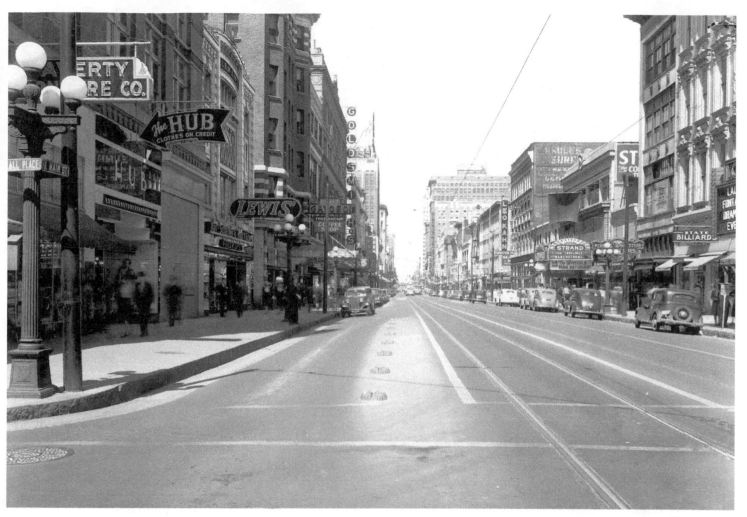

Main and McCall, circa 1939.

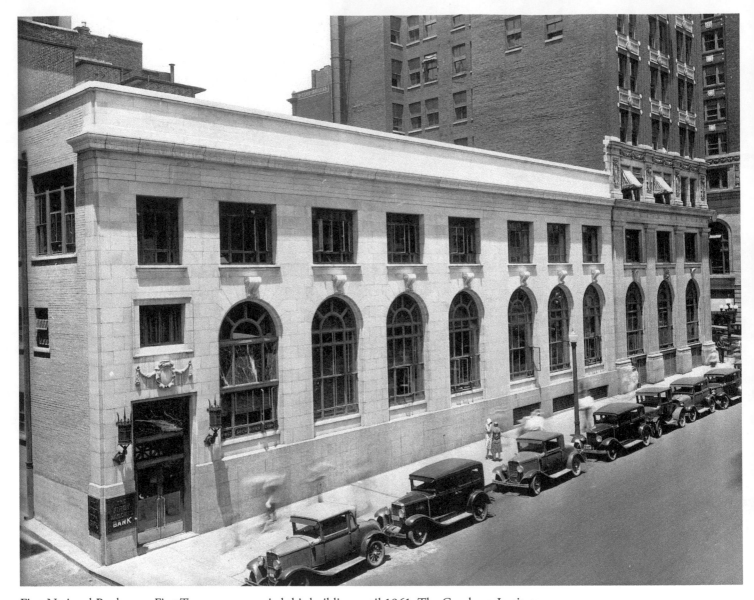

First National Bank, now First Tennessee, occupied this building until 1961. The Goodwyn Institute moved into the old bank building, while the bank bought the institute's property, demolished the building, and built a new bank on the site.

A City on the Move

(1940–1959)

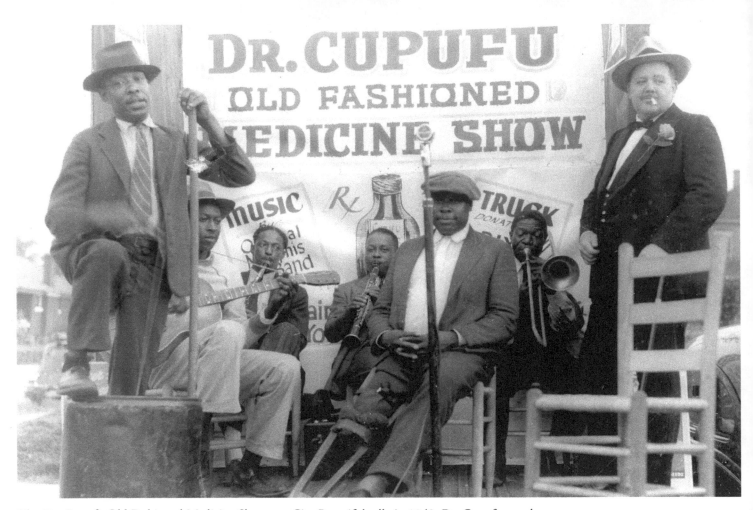

The Dr. Cupufu Old Fashioned Medicine Show at a City Beautiful rally in 1942. Dr. Cupufu stands for the organization's slogan, "Clean Up, Paint Up, Fix Up."

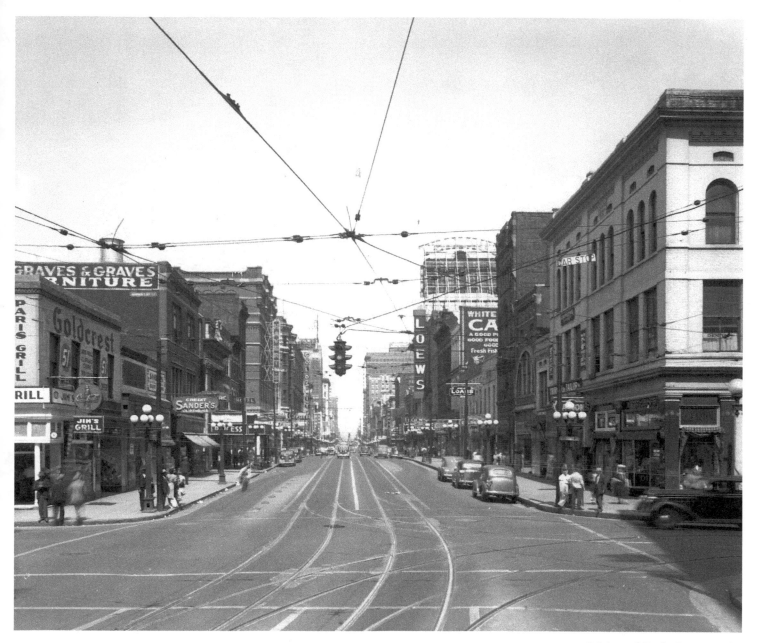

Main and Beale Street, 1940.

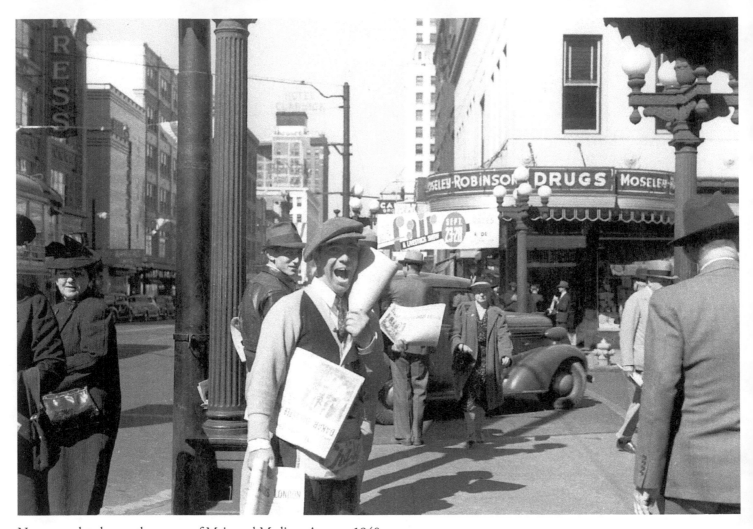

Newspaper hawker on the corner of Main and Madison Avenue, 1940.

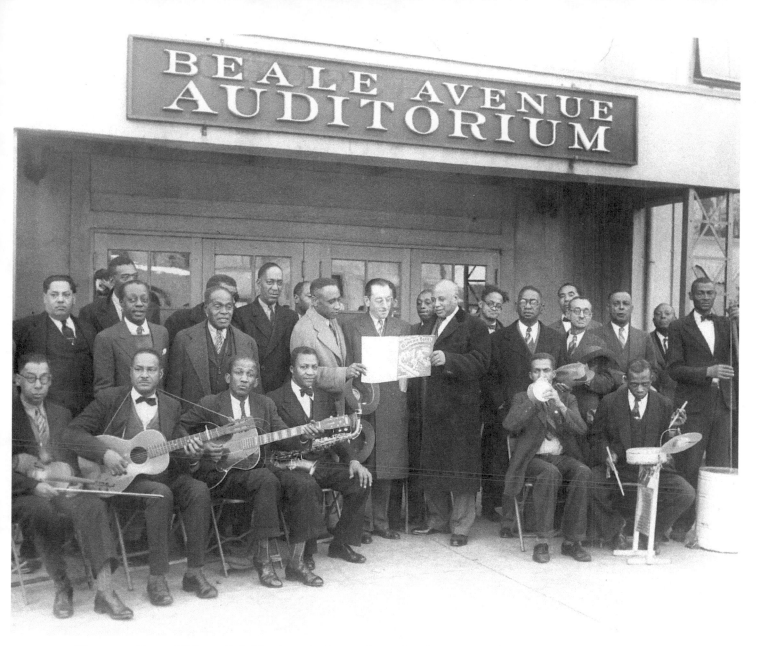

Lieutenant George W. Lee, W. C. Handy, and others in front of Beale Avenue Auditorium in the 1940s. In 1909, W. C. Handy wrote "Mister Crump" about mayoral candidate E. H. Crump. It became his first important song when it was published in 1912 as "Memphis Blues."

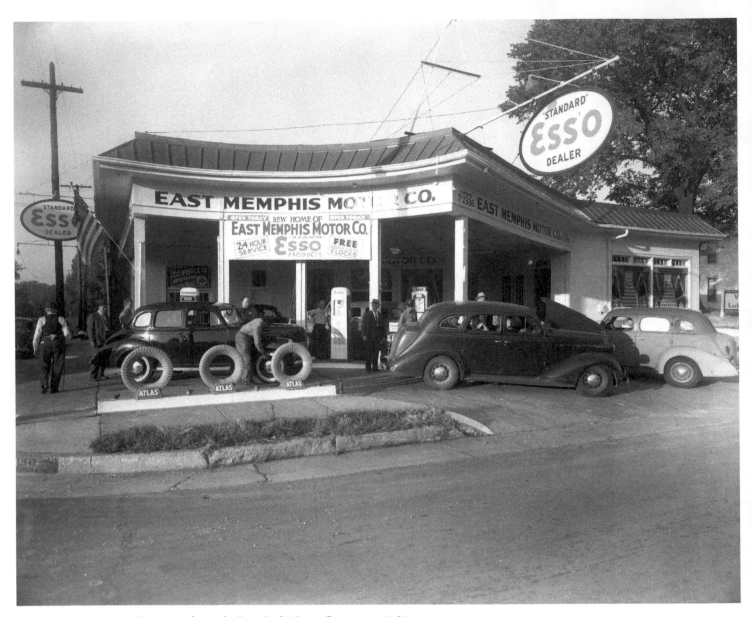

East Memphis Motor Company, formerly East End Motor Company, 1940s.

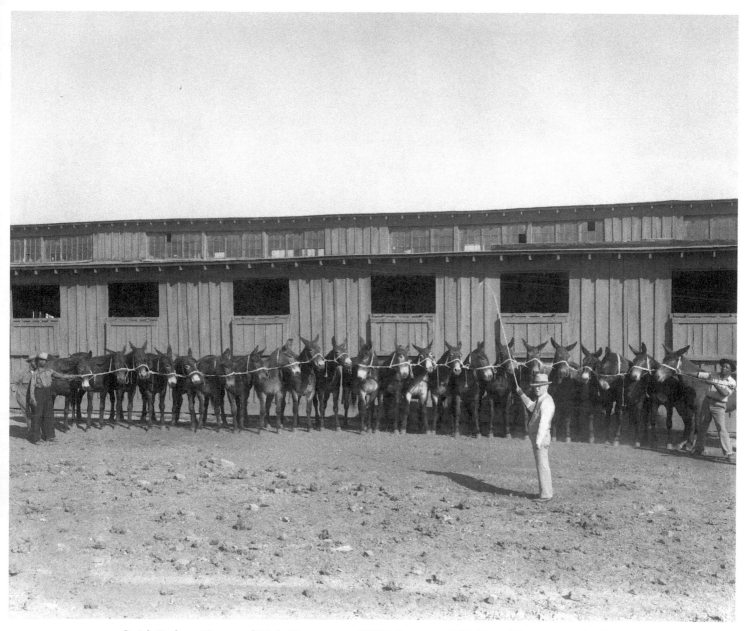

Smith-Podesta Horse and Mule Company at 190 McLemore, 1940. Memphis was considered the largest mule trading market in the country during the first part of the twentieth century.

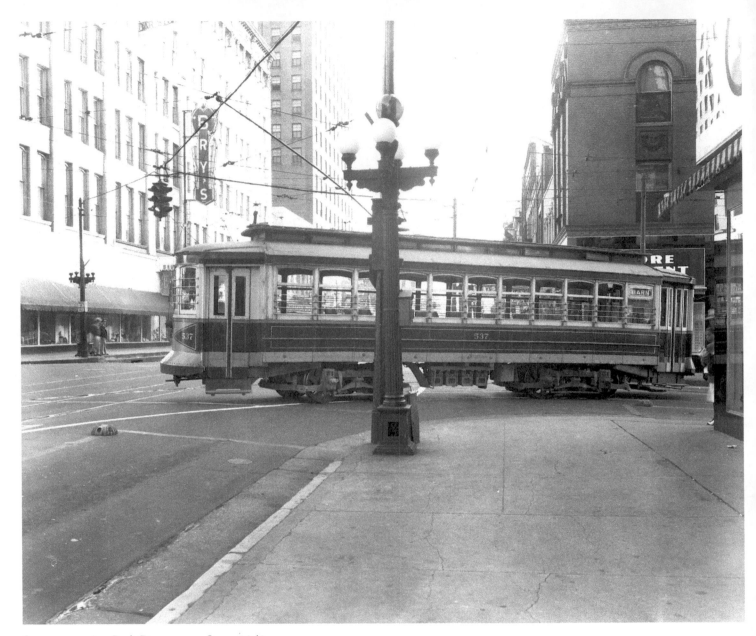

Streetcar passing Bry's Department Store, 1940.

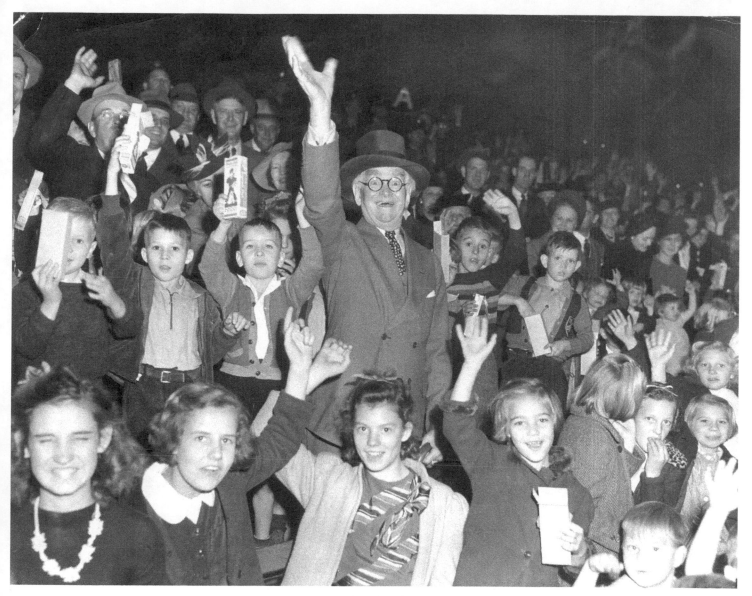

Edward Hull "Boss" Crump attending the circus with schoolchildren, 1942.

Workers making repairs to
streetcar lines, circa 1946.

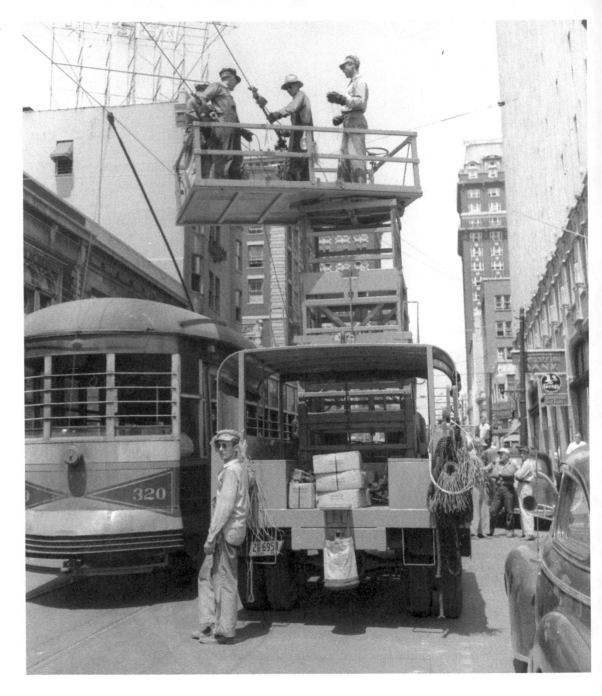

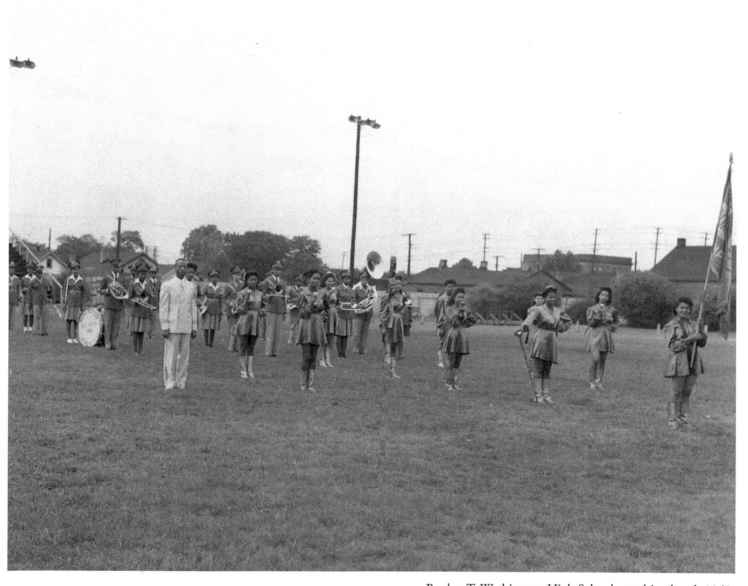

Booker T. Washington High School marching band, 1943.

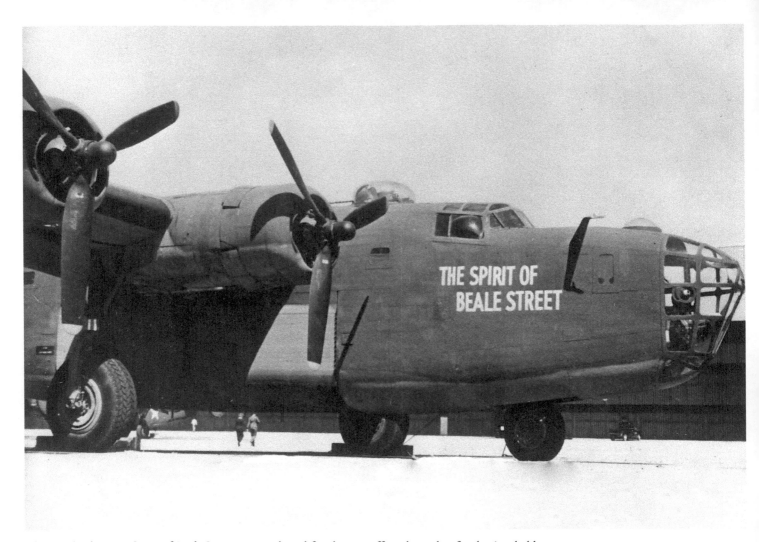

The B-24 Liberator *Spirit of Beale Street* was purchased for the war effort through a fund-raiser led by Lieutenant George W. Lee during World War II.

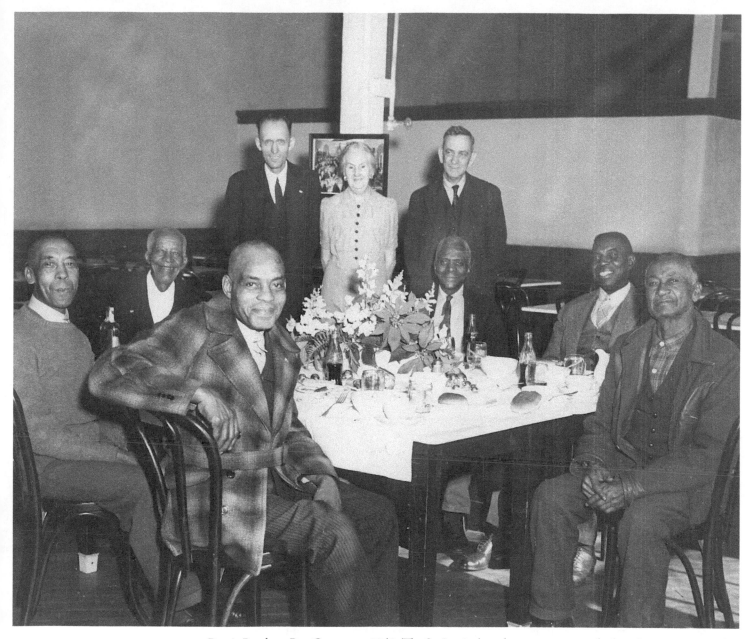

Bemis Brothers Bag Company, 1943. The St. Louis–based company opened a bag factory in Memphis in 1900.

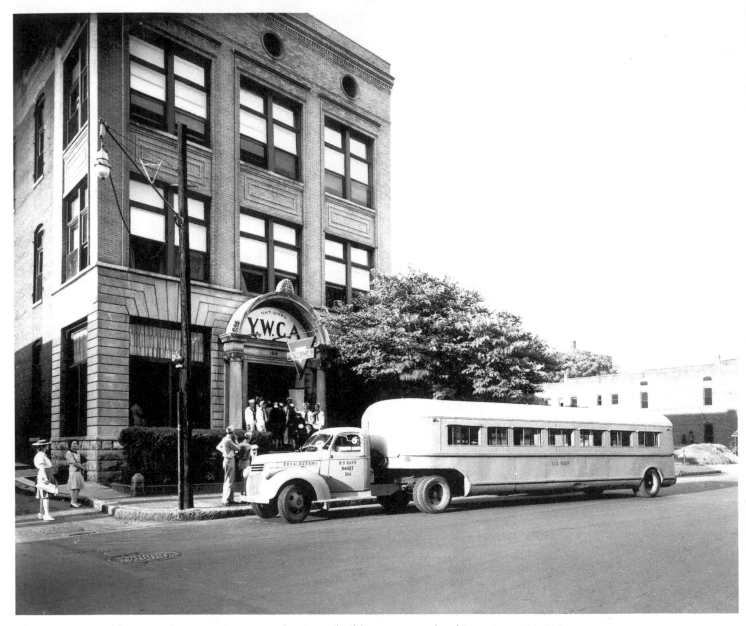

The Y.W.C.A. Building at 196 Monroe Avenue, 1943. A new building was completed in 1951 at 200-202 Monroe Avenue, which later became home to the Salvation Army.

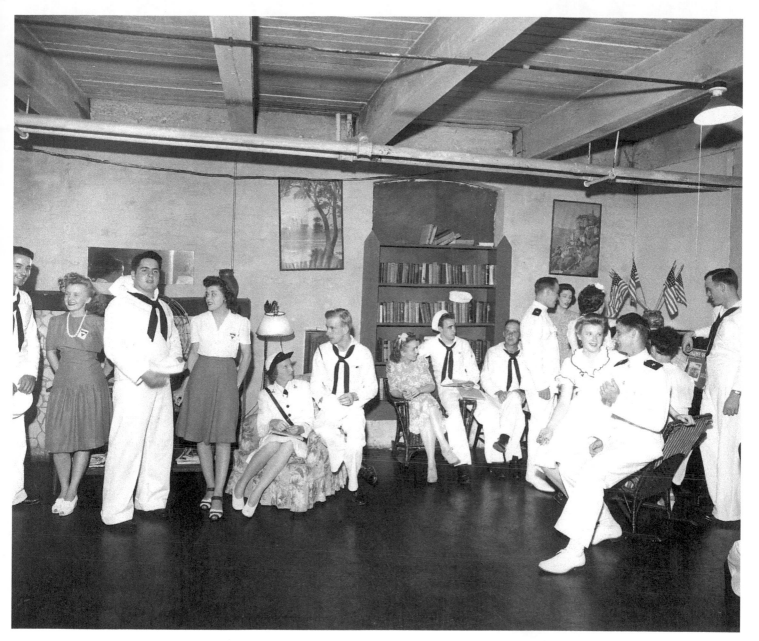

A social gathering at the Y.W.C.A. in 1943.

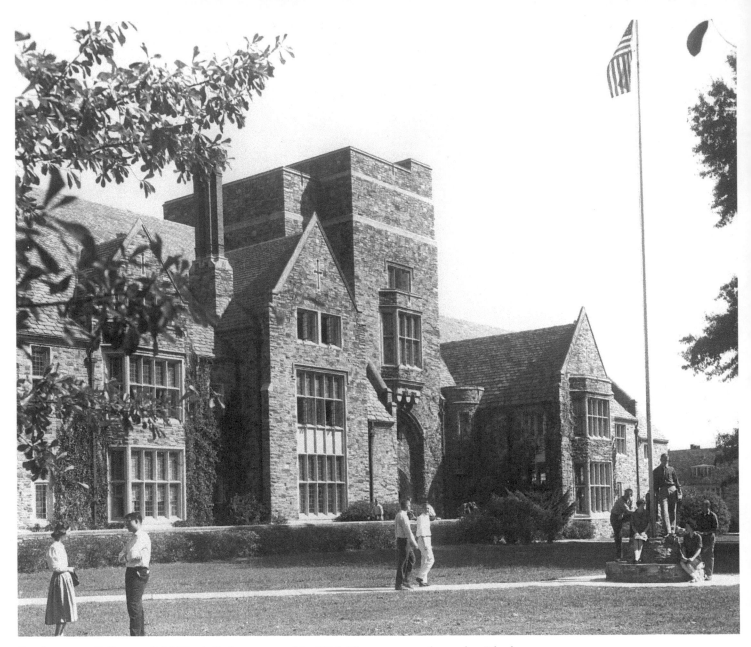

Southwestern College at 2000 North Parkway opened in 1925. The name was changed to Rhodes College in 1984.

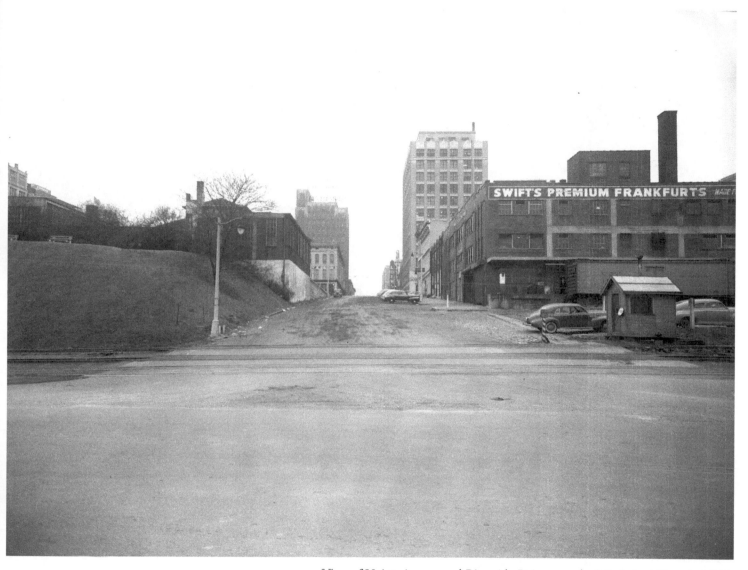

View of Union Avenue and Riverside Drive near the Mississippi River in 1944.

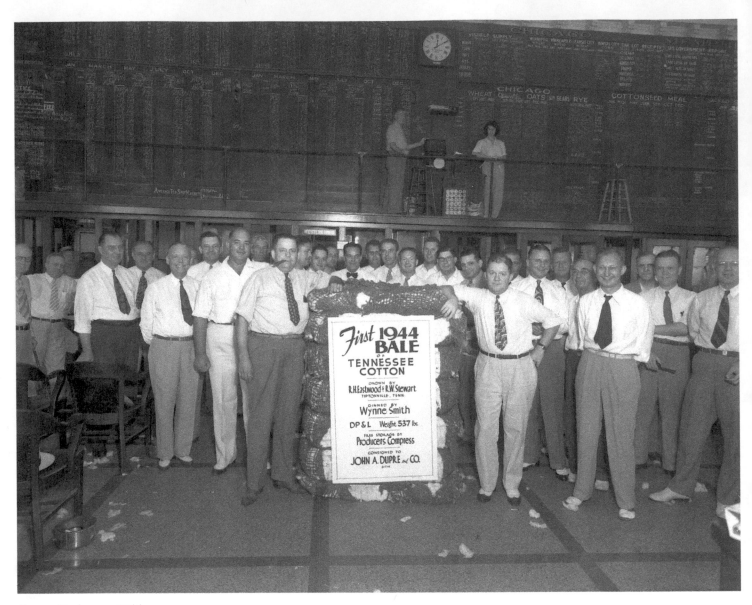

Cotton Exchange, 1944.

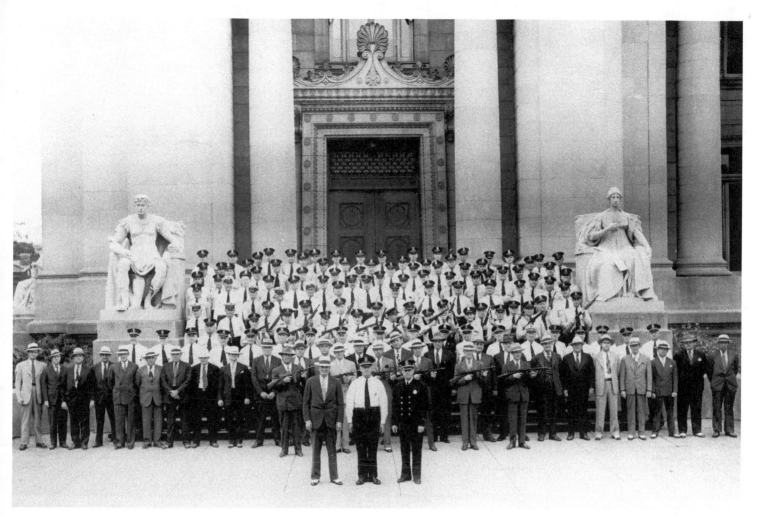

Memphis Police Department, 1944.

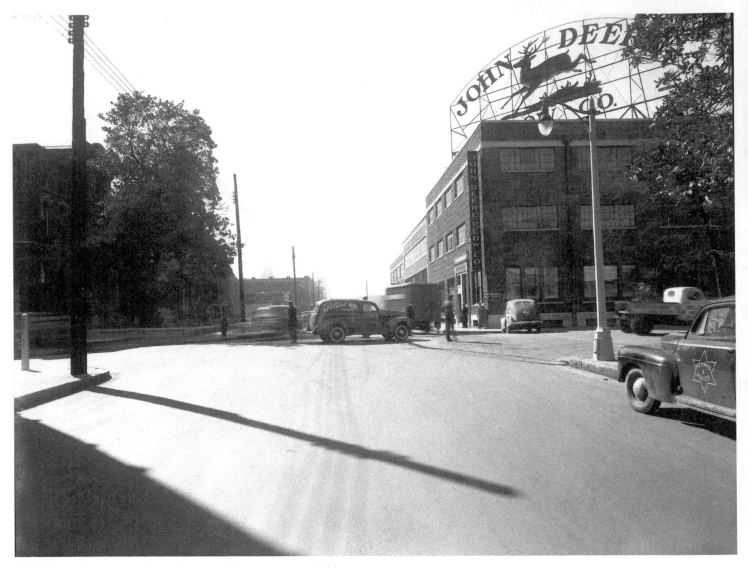

John Deere Company at Front Street and Vance Avenue, 1944.

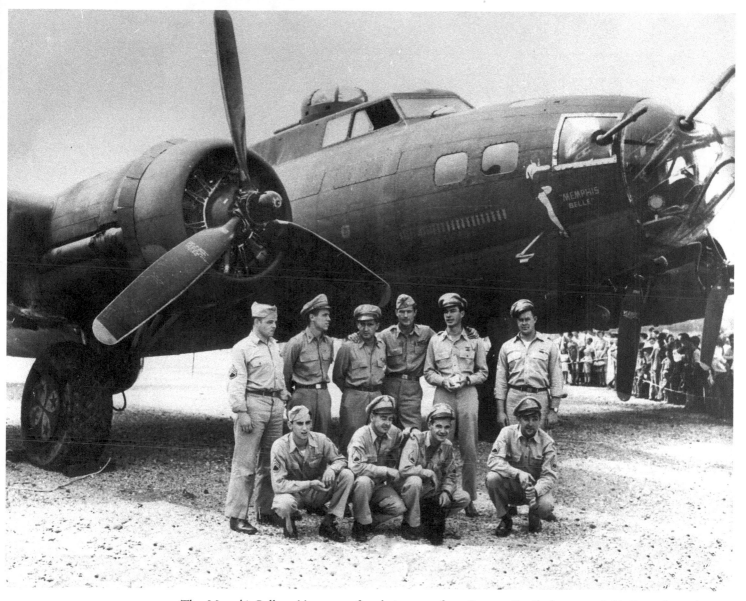

The *Memphis Belle* and her crew after their return from Europe. In all, the crew of this B-17 flying fortress completed 25 combat missions over Europe, earning the thanks and praise of Americans back home.

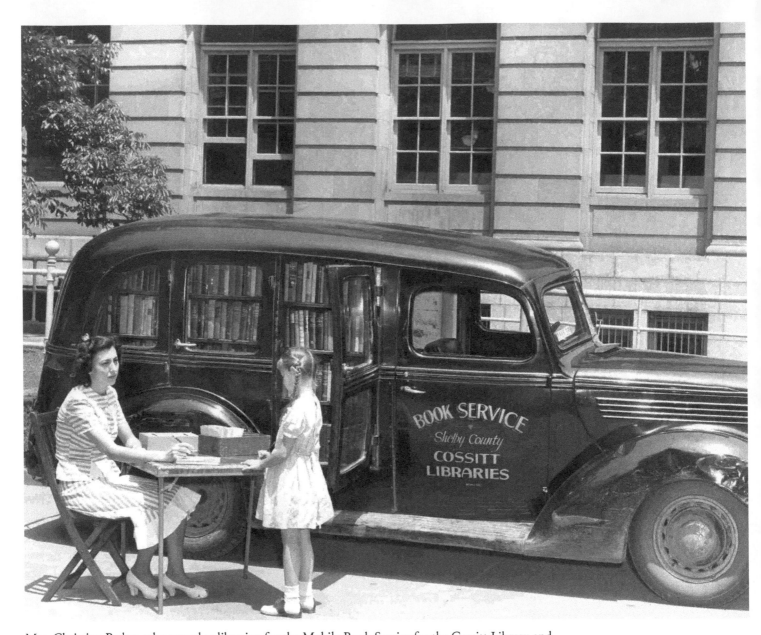

Mrs. Christine Parker, who served as librarian for the Mobile Book Service for the Cossitt Library and Shelby County Libraries, 1947.

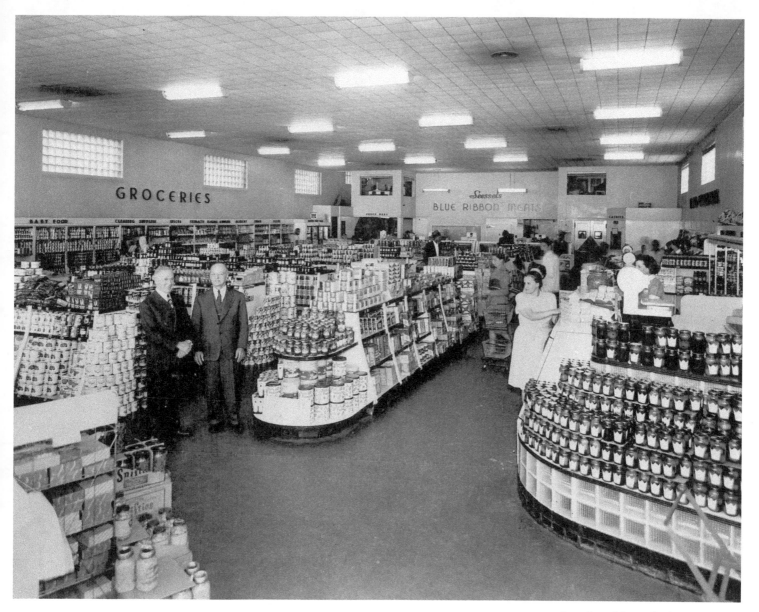

Interior of Seessel's Grocery Store.

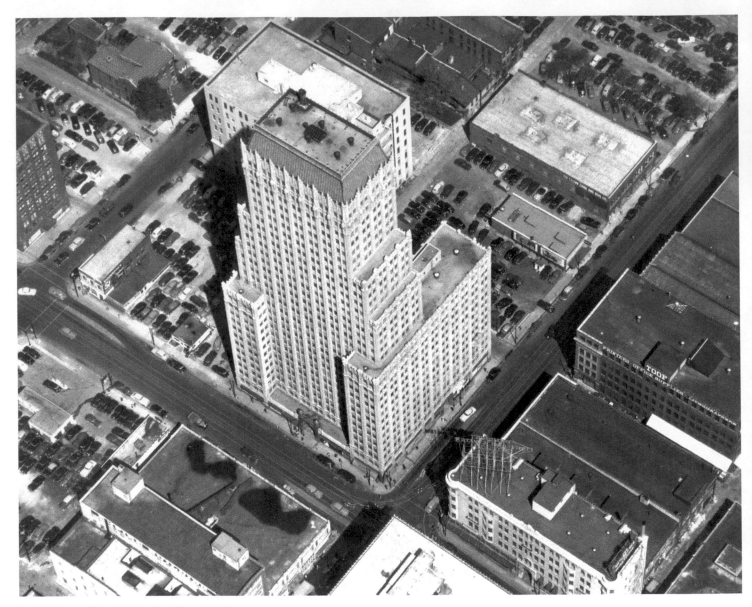

Aerial view of the Sterick Building, 1947.

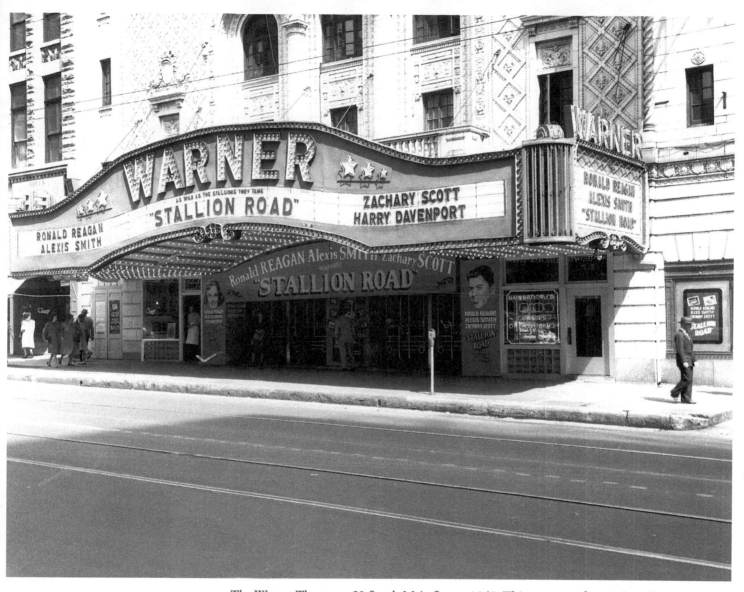

The Warner Theater at 52 South Main Street, 1947. This was one of a number of theaters in the vicinity including Loew's State, the Strand, Princess, and Loew's Palace.

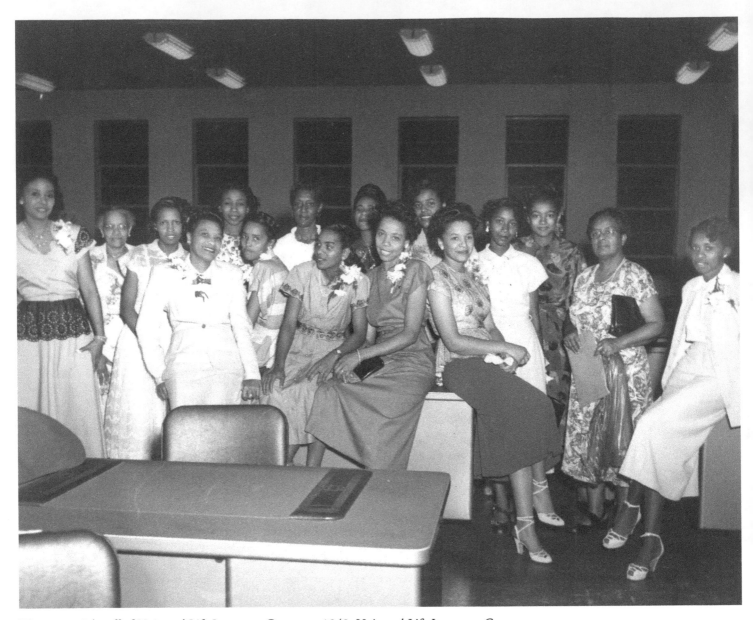

The secretarial staff of Universal Life Insurance Company, 1949. Universal Life Insurance Company was founded by Dr. J. E. Walker in 1923 and operated on the third floor of the Fraternal Bank Building on Beale Street before moving to 234 Hernando in 1930. The company moved again in 1949 into a new building at 480 Linden.

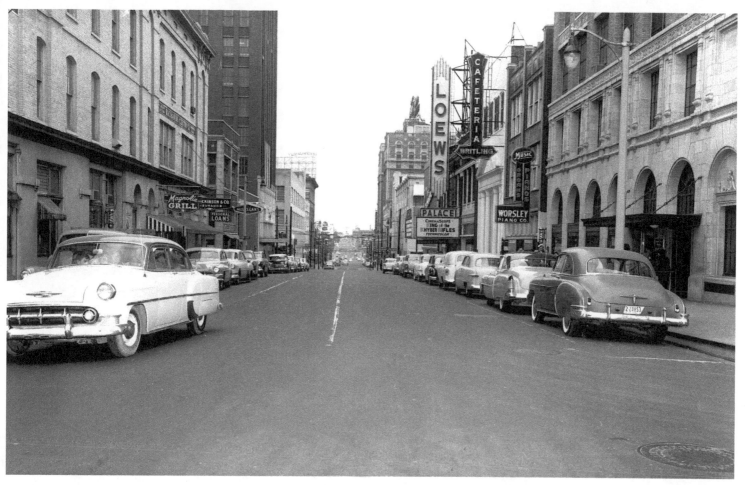

Union Avenue and South Front Street, 1954.

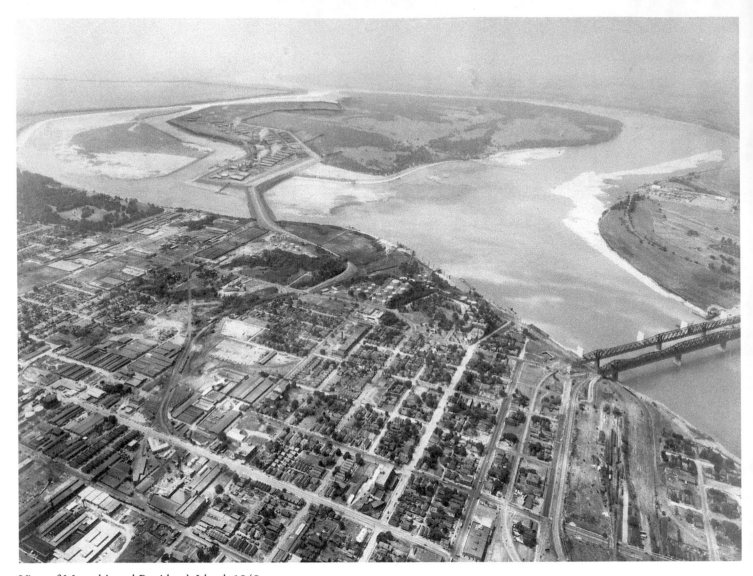

View of Memphis and President's Island, 1948.

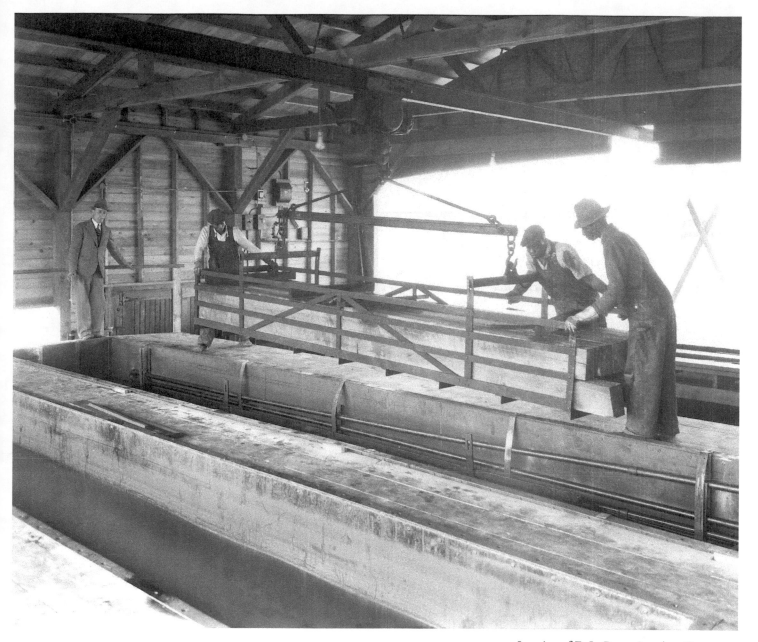

Interior of E. L. Bruce Lumber Company.

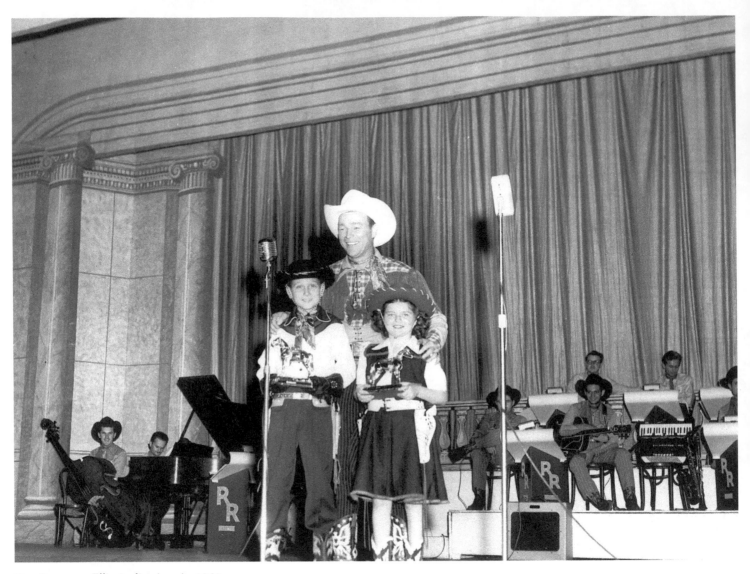

Roy Rogers at Ellis Auditorium in 1950.

Recent Times

(1960–1970s)

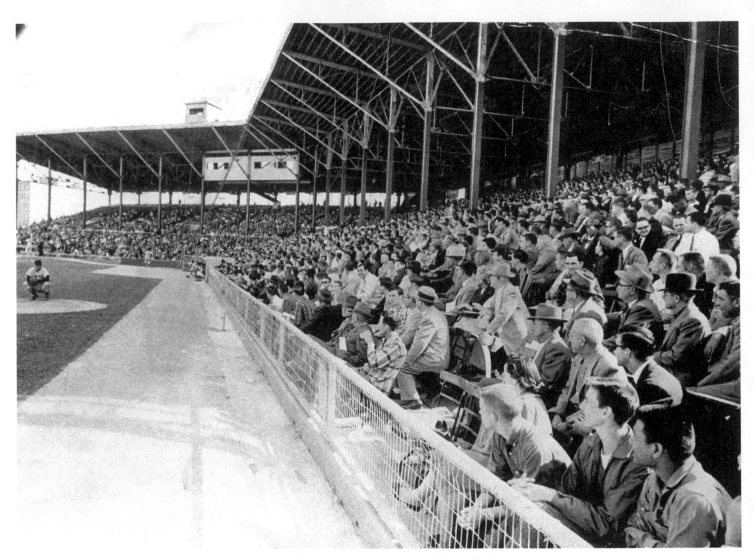

Russwood Park, 1960. Originally named Red Elm Park, the stadium's name was changed in honor of owner Russell E. Gardner by his son-in-law Thomas Watkins in 1915. The park was home to the Memphis "Chicks" baseball team until it was destroyed by fire April 17, 1960.

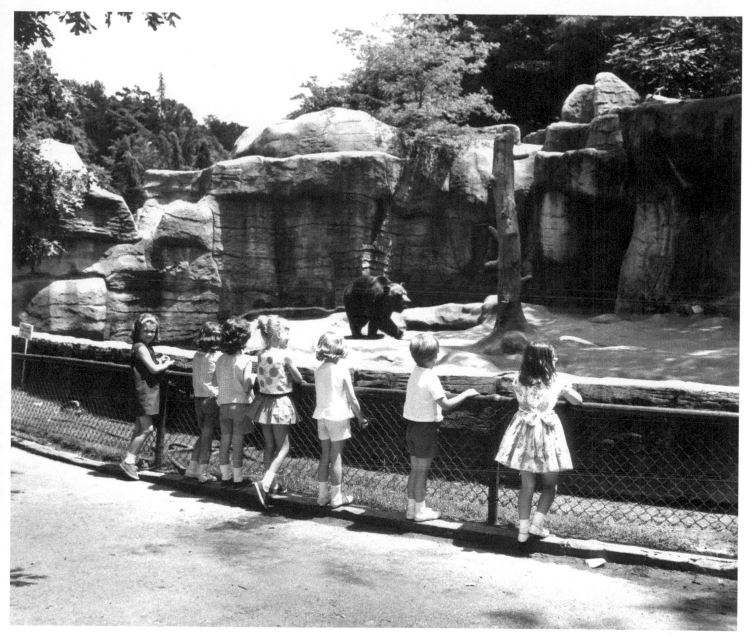

The Memphis Zoo in Overton Park, 1965.

Memphis Metropolitan Airport, 1965. American Airlines offered the first nonstop flight to New York from Memphis beginning July 6, 1965. It was an important step for the airport, which at the time was the 27th-busiest in the country.

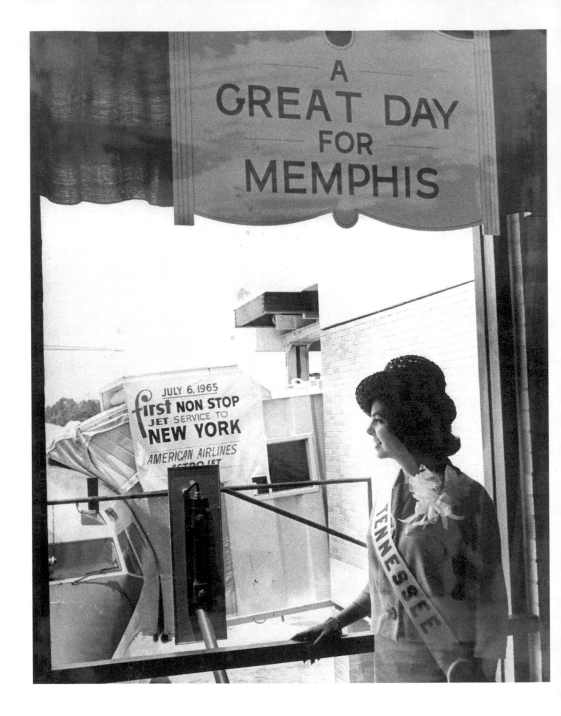

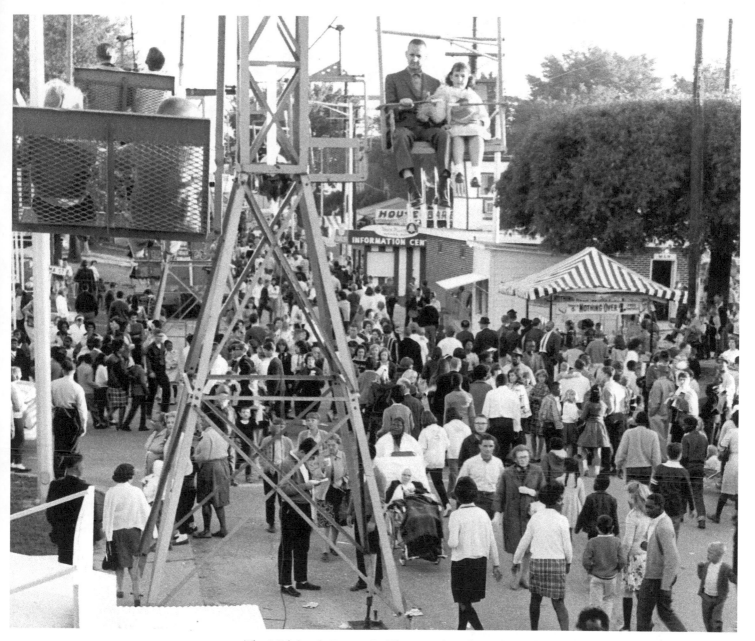

The Mid-South Fair, 1965. The annual Mid-South Fair began in 1856. The fair runs from late September to early October and features shows, livestock exhibits, rides, and concession stands.

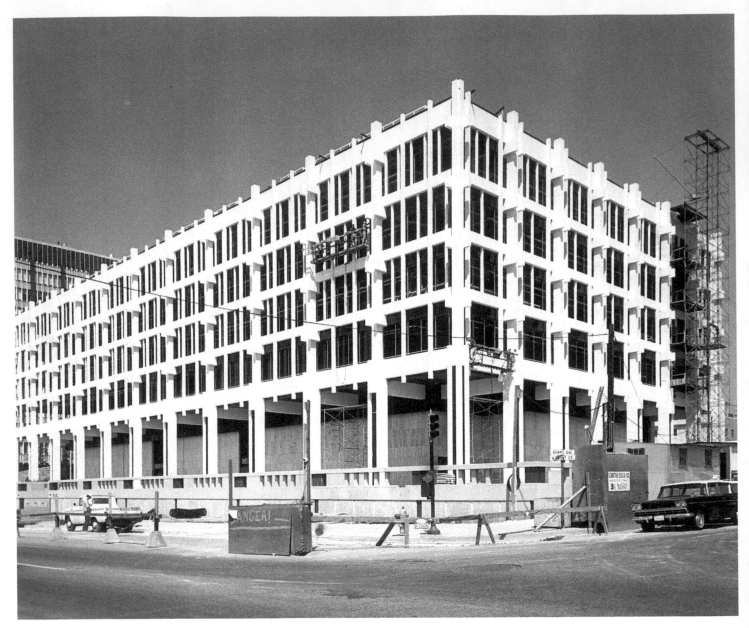

The final stages of construction of City Hall, 1965.

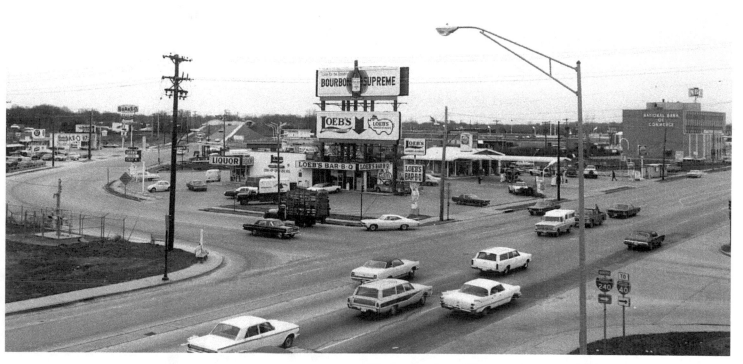

The intersection of Summer Avenue and White Station Road, 1960s.

Edward Kirby, a.k.a. Prince Gabe, and his band the Millionaires were known for performing in area nightclubs and for leading New Orleans–style funeral processions down Beale Street from the 1960s through the 1980s.

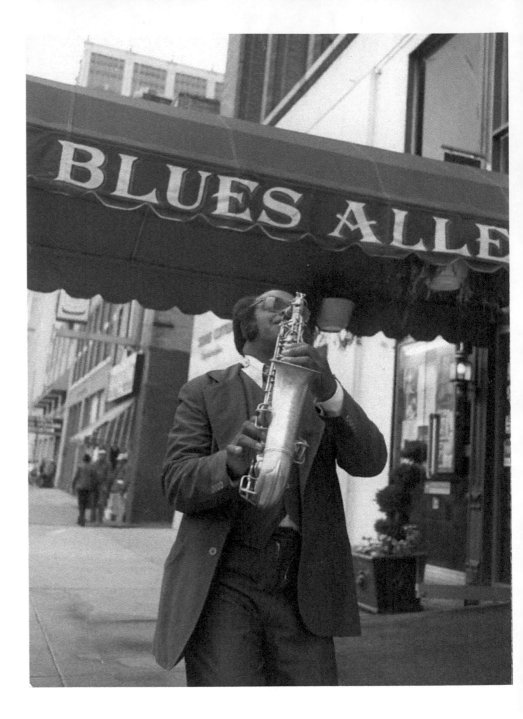

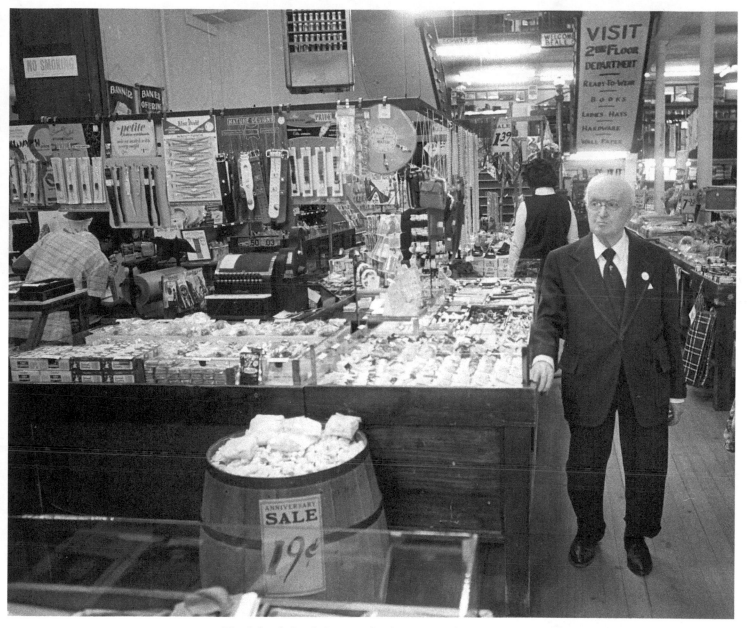

The Schwab family business has been on Beale Street since 1876. Abraham Schwab, pictured here, relocated his dry goods store from 149 to 163 Beale Street in 1912.

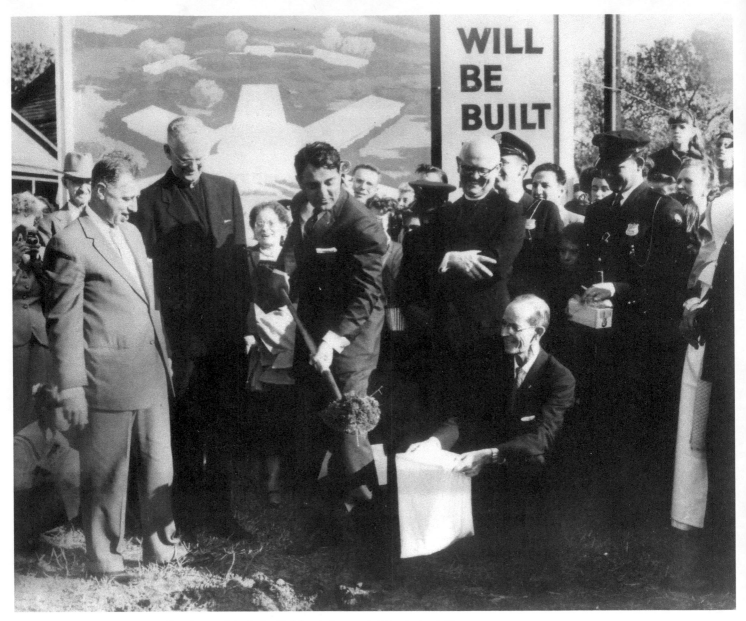

Danny Thomas at the groundbreaking of St. Jude Children's Research Hospital, 1962.

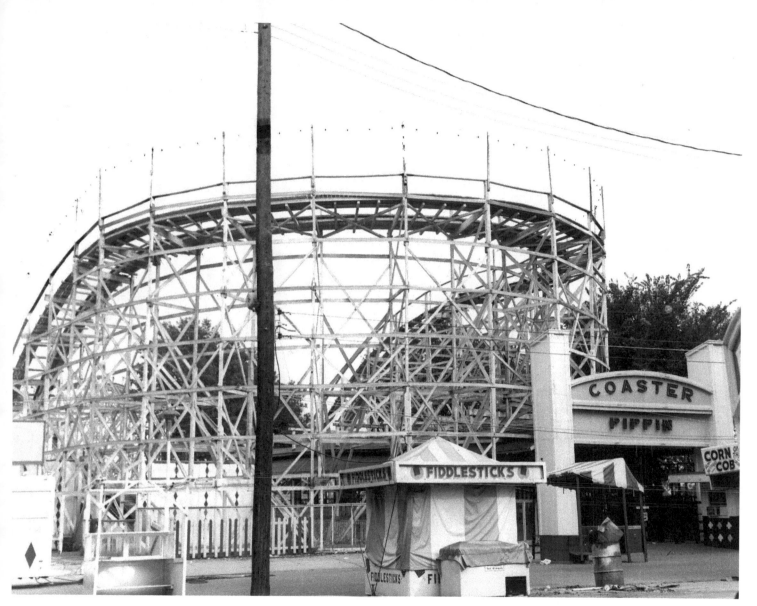

The Pippin Roller Coaster at the Fairgrounds Amusement Park, 1974.

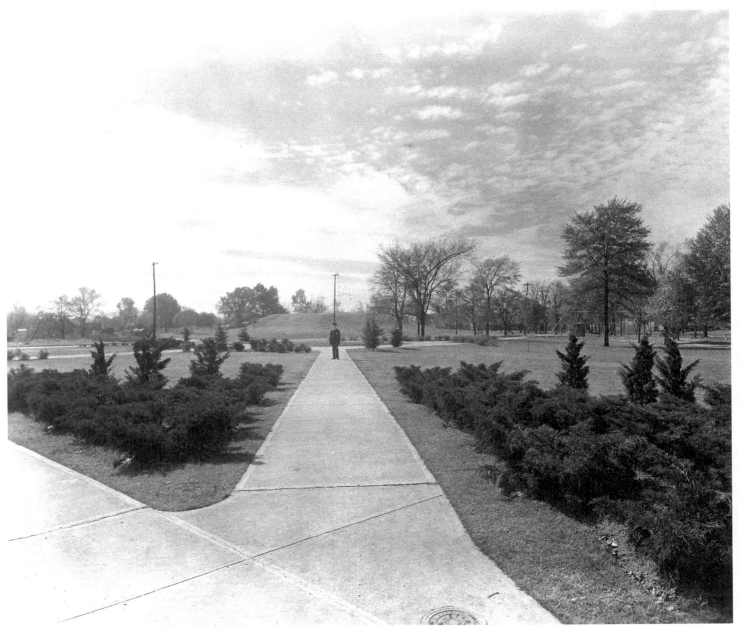

Jackson Mound Park opened in the 1880s and was renamed Desoto Park in 1913. The mound at the back of the photograph is known as Chisca's Mound, after a Native American chief encountered by Desoto. The park was named Chickasaw Heritage Park in 1995.

Notes on the Photographs

These notes attempt to include all aspects known of the photographs. Each of the photographs is identified by the page number, photograph's title or description, photographer and collection, archive, and call or box number when applicable. Although every attempt was made to include all data, in some cases complete data may have been unavailable.

18 RALEIGH SPRINGS CAR LINE
Memphis Public Library
Memphis and Shelby County Room
1911N

19 JAMES LEE HOUSE
Memphis Public Library
Memphis and Shelby County Room
3568C 52
From the Municipal Reference
Library

20 FRONT STREET, 1895-1900
Memphis Public Library
Memphis and Shelby County Room

4

21 ORGILL BROTHERS
Memphis Public Library
Memphis and Shelby County Room
3658C 468
Courtesy of Henry Frank, c. 1915

22 BOHLEN-HUSE ICE COMPANY
Memphis Public Library
Memphis and Shelby County Room
1543

23 GAYOSO HOTEL
Memphis Public Library
Memphis and Shelby County Room
1797C 3026

24 ILLINOIS CENTRAL DEPOT
Memphis Public Library
Memphis and Shelby County Room
876NC 2211

25 UNION AVENUE, 1895
Memphis Public Library
Memphis and Shelby County Room
605C 5252

26 THE *PETERS LEE* RIVERBOAT
Memphis Public Library
Memphis and Shelby County Room
2436
Donated by Miss Bert Wade
Photo by Coovert, No 1206

28 PRESIDENT WILLIAM
McKINLEY, 1901
Memphis Public Library
Memphis and Shelby County Room
7811C 6719
Apply for copies to Pink Palace
Accession no.; 194

29 THE COTTON EXCHANGE
Memphis Public Library
Memphis and Shelby County Room
1461C 1183

30 HARDWOOD CAPITAL OF THE
WORLD
Memphis Public Library
Memphis and Shelby County Room

31 ST. PETER'S CATHOLIC
CHURCH
Memphis Public Library
Memphis and Shelby County Room
1396C 1934

32 ST. PETER'S INTERIOR
Memphis Public Library &
Information
Center
Memphis and Shelby County Room
6661NC 1935
Photo by Poland

33 RALEIGH SPRINGS
Memphis Public Library
Memphis and Shelby County Room
2932C 4313

34 RALEIGH SPRINGS RESORT
Memphis Public Library
Memphis and Shelby County Room
1474

35 MULE-DRAWN COCA-COLA
WAGON
Tennessee State Library and
Archives
Looking Back at Tennessee
TP106, Accession No. 1988-017

36 LOCAL BASEBALL TEAM
Memphis Public Library
Memphis and Shelby County Room
7917C 984
Gift of Memphis Police Department

37 MONTGOMERY PARK
Memphis Public Library
Memphis and Shelby County Room
5936C 2840
Gift of Henry Frank

38 *GREY EAGLE* AND *ALTON*
Memphis Public Library
Memphis and Shelby County Room
Robert J. Gasper Collection

39 MAIN STREET
Memphis Public Library
Memphis and Shelby County Room
1970C 5114

40 FIRST SCHOOL BUS
Memphis Public Library
Memphis and Shelby County Room
1925

41 NAT EDWARDS AND CO.
LIVERY STABLES
Memphis Public Library
Memphis and Shelby County Room
3548C 3757

42 BUSINESS MEN'S CLUB
Memphis Public Library
Memphis and Shelby County Room
3554C 3999

43 EAST END PARK MERRY-GO-
ROUND
Memphis Public Library
Memphis and Shelby County Room
4395C 4293
Gift of Mrs. Patricia Stegall Kolwyck

44 COURT SQUARE FOUNTAIN
Memphis Public Library
Memphis and Shelby County Room
2148N

45 FLOOD, 1912
Memphis Public Library
Memphis and Shelby County Room
2740C 2497
Photo by Coovert, No 1437

Printed in the USA
CPSIA information can be obtained
at www.ICGtesting.com
JSHW072025140824
68134JS00042B/3784

9 781683 368533